IMAGES
of America

FRONTIER VILLAGE

FRONTIER VILLAGE
AMUSEMENT PARK!

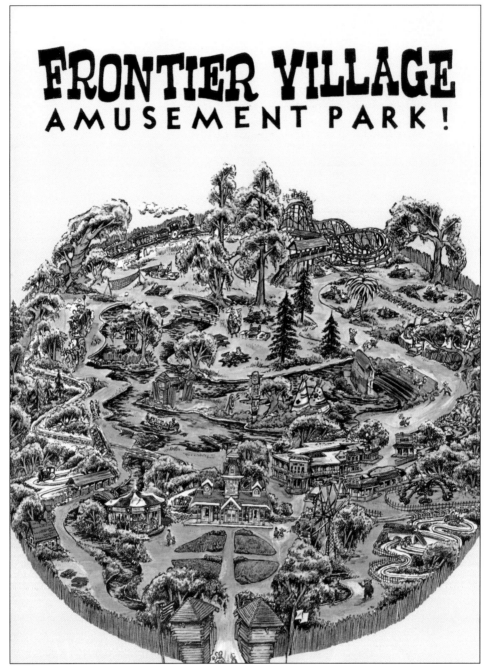

This map of Frontier Village shows the park at its peak in the late 1970s. The main entrance at the bottom is flanked by two blockhouses leading into the Central Square. At the rear of the square is the Victorian-style train station. In the center is Indian Island with tipis and a totem pole. At the top, the Frontier Village train steams along the park's edge.

ON THE COVER: Paul Stolp drives the Frontier Village Stagecoach past the stockade of Fort Far West. In the far background are the docks for Indian Jim's Canoes.

IMAGES of America

FRONTIER VILLAGE

Bob Johnson
Foreword by Allen Weitzel

ARCADIA
PUBLISHING

Published by Arcadia Publishing
Charleston, South Carolina

Printed in the United States of America

Library of Congress Control Number: 2012948357

For all general information, please contact Arcadia Publishing:
Telephone 843-853-2070
Fax 843-853-0044
E-mail sales@arcadiapublishing.com
For customer service and orders:
Toll-Free 1-888-313-2665

Visit us on the Internet at www.arcadiapublishing.com

*To Joe Zukin, whose vision, drive, and business skills
brought Frontier Village to life*

CONTENTS

ACKNOWLEDGMENTS

This book could not have been written without the assistance of a number of people and institutions. First among them is my wife, Lauren Miranda Gilbert. After I had talked for months about writing a book about Frontier Village, Lauren encouraged me to finally start researching and writing. Her steadfast support during this project was much appreciated, as was her proofreading of the final draft. Unless otherwise noted, the book's images are courtesy of the Frontier Village Collection housed in the California Room of the San Jose Public Library. I want to thank senior librarians Sandra Stewart and Angie Miraflor for their permission to use images from this collection. I also want to thank the staff of the California Room for their ongoing help during the writing of the book. Some of the images came from the Sourisseau Academy for State and Local History at San Jose State University; I want to thank executive secretary Charlene Duval for permission to use them. Tim Stephens generously gave me access to his outstanding collection of Frontier Village photographs and memorabilia and allowed me to use a number of them in this book. Thank you, Tim! Special thanks must be made to Allen Weitzel. I contacted Allen when I first started researching the book and found him to be enthusiastic and helpful. Allen was my go-to man whenever I had a question about Frontier Village history or needed help in identifying a photograph. If Allen could not draw upon his 15 years of experience working at Frontier Village to answer my question, he would pass it on to his circle of former Frontier Village managers and employees for their input. Allen also allowed me to draw from his collection of Frontier Village photographs to use in the book. Finally, Allen and his brother Warren read my final draft and suggested a number of corrections and clarifications, for which I am extremely grateful. Allen deserves much of the credit for the final form of the book.

FOREWORD

Bob Johnson came to me through a mutual colleague who remembered my employment at Frontier Village (FV). Bob outlined this book and his need for someone to supply or verify facts about the park and the employees. Having spent 15 seasons at FV, I felt obligated to the FV legions to help Bob make this book as accurate as possible.

Both guests and employees loved Frontier Village. Joseph Zukin Jr., the founder, certainly deserves recognition for creating a wonderful entertainment facility and a great work environment, especially for many Santa Clara Valley youth whose first jobs were at FV.

"The Village" was a unique experience for all who worked there. Joe created an operation with charm, fun, and solid American business ethics. Teamwork was important; strong egos and office politics were unwelcome. He took us all under his management wing and educated us on proper business procedures, with the guests' enjoyment being our top priority.

FV employees were the cream of the crop, facing rigorous screening to get hired and then meticulously trained on their duties. The employees were proud to be working in an exceptional operation. FV cowboys and cowgirls were attractive, polite, wholesome, and friendly. They enjoyed their jobs and shared their enjoyment with the guests. Everyone worked hard and had fun. To this day, former employees still rave about the lessons they learned while working with guests, vendors, and fellow "FV hands." FV was a Camelot within the amusement industry.

For the guests, FV was genuine. Honest, clean, customer focused, safe, inexpensive, and one of the first parks (after Disney) to combine art and imagination into the amusement experience. The park was beautifully landscaped. The design was intriguing and inviting. Guests were encouraged to explore and seek out distinctive attractions, such as the canoes, archery, trout fishing, gunfights, the Spirit of Kitty Hawk, or the old schoolhouse, all while enjoying themed background music. Guests always praised the park's cleanliness. Where else could children talk to a cowboy marshal, watch authentic Indian dancing, or shake hands with big, fuzzy Theodore Bear? Frontier Village was fantasy for children and an escape for parents.

The FV staff all learned and grew together, as friends and business professionals, and gave the paying public more than their money's worth. They provided guests fond memories of the fastest fun in the West!

—Allen F. Weitzel
Frontier Village employee from 1966 to 1980

INTRODUCTION

In the mid-1950s, a trip to Disneyland inspired San Jose businessman Joe Zukin to dream of building his own amusement park in San Jose. He hired movie-set and amusement-ride designer Laurie Hollings to plan the park. The park's theme was to be the Wild West, which Zukin thought would appeal to both children and adults. Zukin and his backers purchased 33 acres of the former Hayes Estate in south San Jose to house the park. The Hayes Estate, with its grand house and 600 acres of farmland and park, was first owned by noted 19th-century spiritualist Mary Hayes Chynoweth and then by her sons Everis and Jay, longtime publishers of the *San Jose Mercury* newspaper.

Construction started in 1960 and was completed the following year at a cost of $3 million. The park opened on November 4, 1961. The entrance led into a town square with a Victorian-style train station. The park's core was Main Street with the Silver Dollar Saloon, Marshal's Office and Jail, and various shops and concessions. Main Street was the site of hourly staged gunfights between the marshal and assorted bad guys. Surrounding Main Street were rides such as the Ferris Wheel, Merry-Go-Round, Sidewinder, and Round-Up. The Frontier Village train gave visitors a mile ride around the periphery of the park, while a stagecoach and burro rides offered visitors a glimpse of the former landscaped grounds of the Hayes Estate.

Frontier Village was a popular attraction from its beginning. Attendance grew, and the park management encouraged return visits through clever marketing and the addition of new rides and attractions each year. In 1970, the park expanded from 33 to 49 acres, allowing additional rides and more parking. In the late 1970s, the park was averaging between 425,000 and 450,000 visitors a year. The park employed 300 to 400 high school and college students each year to its staff.

In 1976, Frontier Village faced serious competition when Marriott's Great America Amusement Park opened about 10 miles north in the city of Santa Clara. Great America was a modern amusement park featuring thrill rides not found in the smaller Frontier Village. The owners of Frontier Village knew they would have to expand in order to survive. They proposed doubling the size of the park. But in the years since its opening, the vacant land surrounding the park had been built up with housing. These residents objected to the park's expansion, fearing it would bring more traffic, noise, and crime to the area. After years of delays, the park's expansion was finally approved. But, by then, the park's owners decided the expansion of Frontier Village was not a good investment, and the park was to be sold. After one final season, the "Last Round-Up," the park closed forever on September 28, 1980. Part of the land was sold for condominiums, and part was purchased by the City of San Jose to establish Edenvale City Park.

Today, a walk through Edenvale City Park will find only the faintest of traces that a thriving amusement park once stood. But what remains strong so many years after the park's closing is the fond memories of Frontier Village for those who visited or had worked there.

I hope this book will entertain and educate readers about Frontier Village. Most of all, I hope it will help keep alive the memories of this magical place.

One

OPENING THE FRONTIER

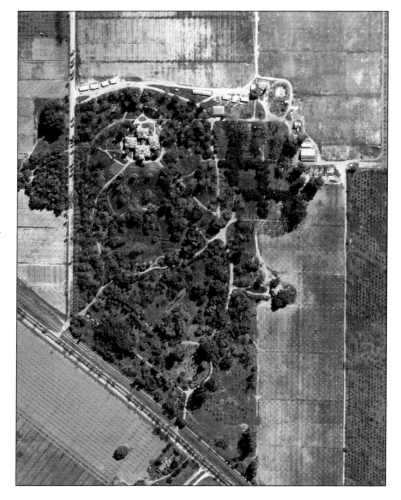

Frontier Village was built on the grounds of the former Hayes Estate in the Edenvale area of south San Jose. In this aerial view taken before park construction, the Hayes Mansion is the large building in the upper left corner. Monterey Highway runs diagonally in the lower left. The park would occupy the forested grounds between the Hayes Mansion and Monterey Highway.

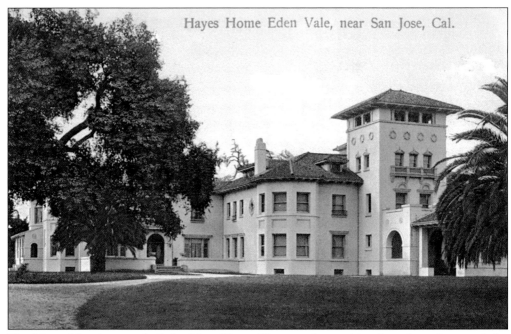

Hayes Home Eden Vale, near San Jose, Cal.

The Hayes Mansion was built by Mary Hayes-Chynoweth, a spiritual teacher who married a wealthy mine owner. The 41,000-square-foot, Mediterranean-style mansion was completed in 1905 and contained 64 rooms. For many years, it was the home of Jay and Everis Hayes, owners of the *San Jose Mercury*. The mansion itself and the surrounding 10 acres were not part of the Frontier Village purchase. The mansion is now a conference center.

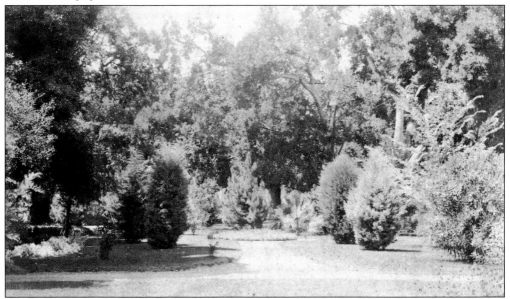

Surrounding the Hayes Mansion was a 40-acre formal garden. The garden was designed by Rudolph Ulrich, who also designed the grounds of the Del Monte Hotel in Monterey. The native oaks were supplemented with exotic imports such as pepper trees, cypress, eucalyptus, palms, and cedars. The lush grounds were the perfect setting for a Western-themed amusement park. (Courtesy of the Sourisseau Academy, San Jose State University.)

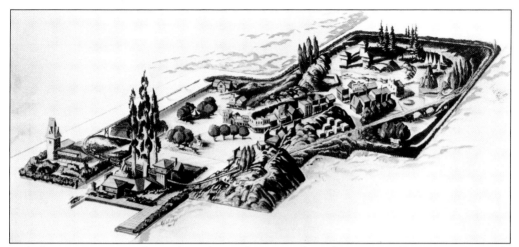

Park designer Laurie Hollings drew this preliminary plan of Frontier Village. Even this early plan shows many of the key design elements that have become identified with Frontier Village, such as the blockhouse, train station, Main Street, and Indian Island. (Courtesy of the Tim Stephens collection.)

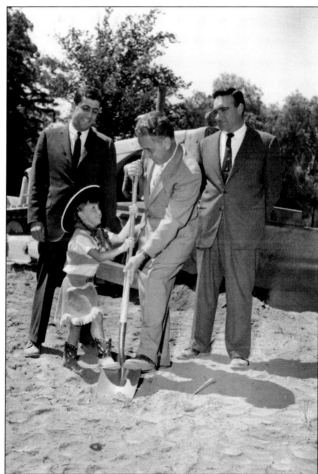

The ground-breaking ceremony for Frontier Village took place on Monday, August 1, 1960, at 3:00 p.m. Wielding the shovel is San Jose mayor Paul Moore, assisted by the daughter of Frontier Village marshal Ron Jabaut. On the left is Michael Khourie, an early investor in Frontier Village. On the right is Joe Zukin, founder and president of Frontier Village. (Courtesy of the Tim Stephens collection.)

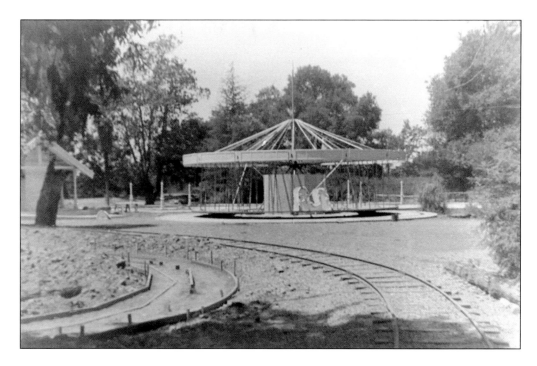

Park construction was partially financed through the sale of Frontier Village stock to thousands of local residents at $5 per share. The park layout was carefully planned to fit into the existing landscape. Only four trees had to be removed during construction. Under construction here is the Merry-Go-Round with railroad tracks passing nearby (above). Work has also started on the Frontier Village Train Station (below). (Below, courtesy of the Tim Stephens collection.)

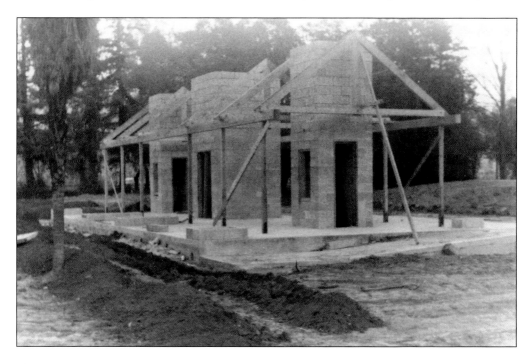

A solitary blockhouse stands on what will eventually become the park's East Gate. After the park was opened, it was used to store hay for the park's animals.

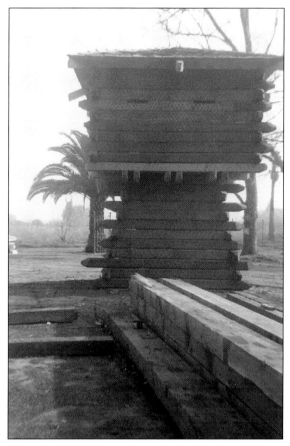

On the left, workmen excavate a large hole that will become the Rainbow Falls Fishing Pond. On the right, wooden forms cover the side of the Lost Frontier Mine Ride. The forms would later be covered with gunite to create the rock-like exterior of the mine ride. (Courtesy of the Tim Stephens collection.)

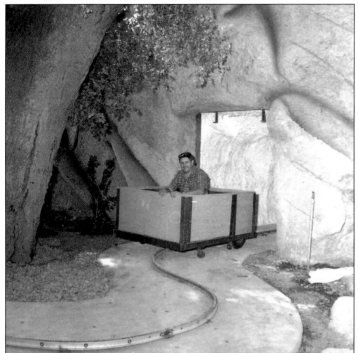

Park designer Laurie Hollings takes a test ride in one of the ore carts that transported visitors through the Lost Frontier Mine Ride, which he also designed. Hollings was an extraordinary jack-of-all-trades with experience as a sculptor, taxidermist, set designer, and amusement park ride planner. His artistic creativity with an engineer's practicality left its impact on the park.

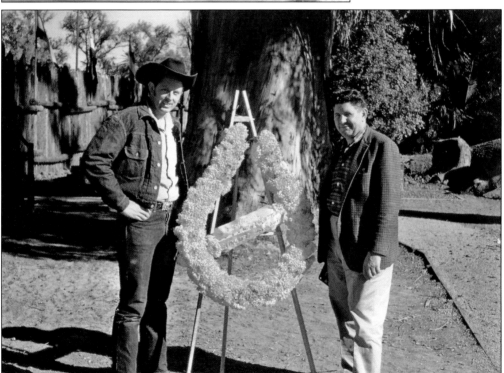

Ron Jabaut (left) and Laurie Hollings pose with a welcome wreath commemorating the opening of Frontier Village. Ron was the first marshal of Frontier Village. (Courtesy of the Tim Stephens collection.)

Two

THE HEART
OF THE VILLAGE

Frontier Village opened on November 4, 1961. This was late in the year to do so, but Joe Zukin had promised the citizens of San Jose that the amusement park would open as soon as it was completed. This early map of Frontier Village shows the rides and attractions that were available in the first years of the park.

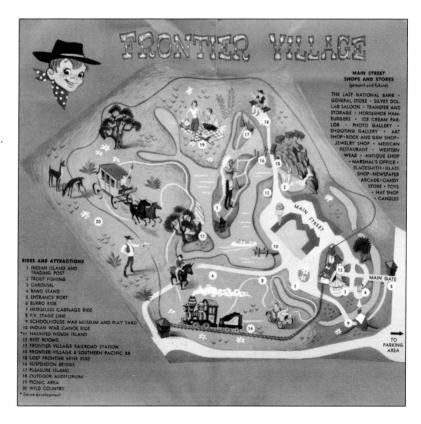

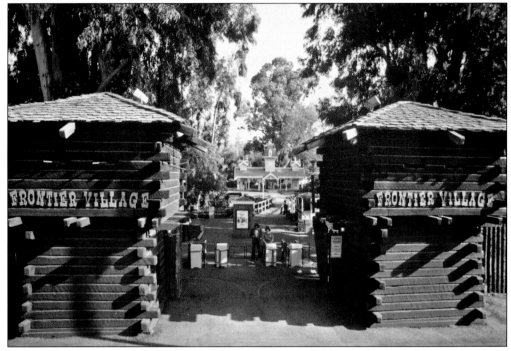

This is the view that probably evokes the most memories for former Frontier Village employees and visitors. It is the main entrance of the park flanked by two wooden frontier blockhouses. The entrance brought visitors into the Central Square, and the Frontier Village Train Station is seen in the background.

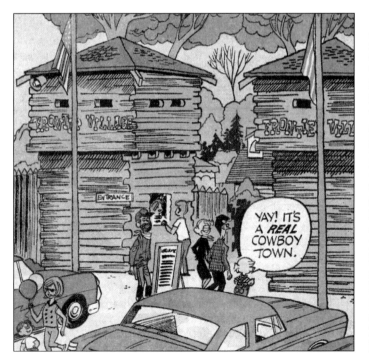

In May 1969, *Dennis the Menace* writer Fred Toole visited Frontier Village in search of story ideas for the comic. The result was "The Park Lark," a story that appeared in *Dennis the Menace* No. 107, distributed in March 1970. The story was reprinted in the *Dennis the Menace Bonus Special* No. 164, "Just Kidding," which was released in May 1977. Here, Dennis and his family are entering the Village through the blockhouse entrance. (*Dennis the Menace* ® used courtesy of Hank Ketcham Enterprises, Inc. and © North America Syndicate.)

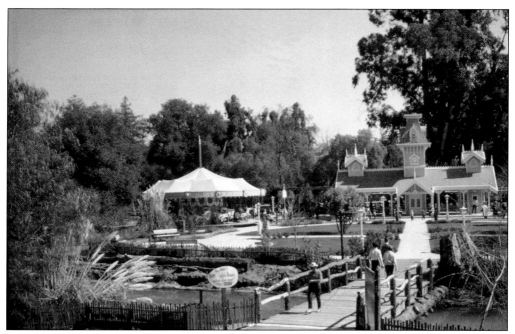

From the entrance, a bridge crossed one of the park's canals and led visitors into the Central Square. The square was a welcoming area with large lawns bordered by paths and inviting benches. From here, guests could visit the Frontier Village Train Station (right) or the Merry-Go-Round (left).

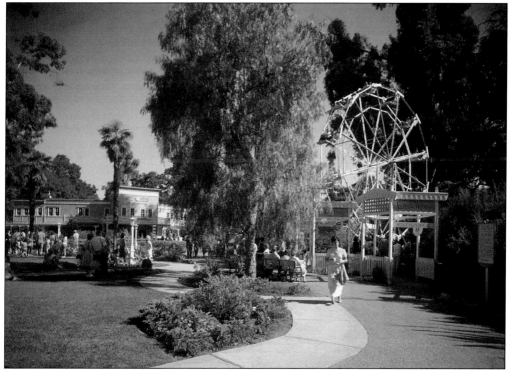

To the right of the Central Square was the Ferris Wheel. Beyond the Ferris Wheel is the path that led to Frontier Village's Main Street.

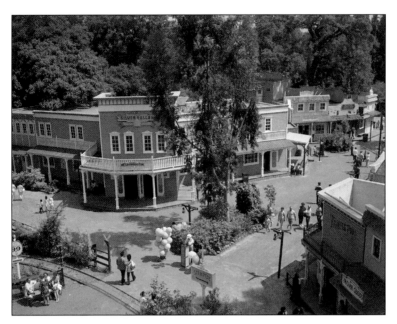

Frontier Village's Main Street transported visitors to a storybook town of the Old West from the 1890s. Every Western town had at least one saloon, and the first building visitors saw entering Main Street was the Silver Dollar Saloon with its balcony. Many of the buildings along Main Street had two stories, with the second story being used as office space for park managers.

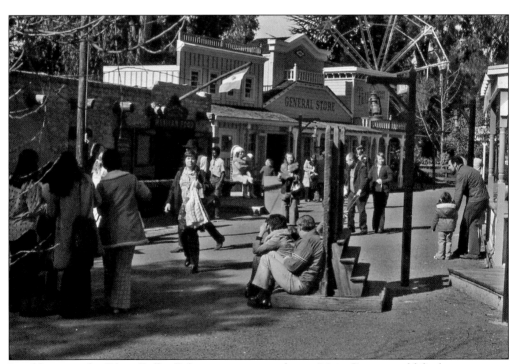

In addition to the Silver Dollar Saloon, visitors wandering Main Street would find a newspaper office, the General Store, Marshal's Office and Jail, Arcade, the Last National Bank, and places to eat and shop. The two men in the foreground sit at the base of the town pillory, while in the left background a wooden Indian sits in front of the General Store.

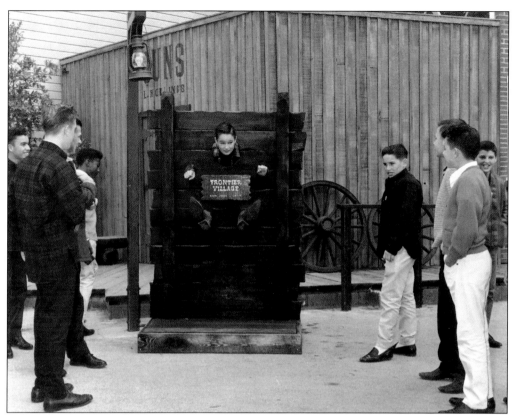

The town pillory was a popular place for taking souvenir photographs. It looks like an uncomfortable pose, but the person is actually standing behind the pillory and sticking only his head and arms through the holes; the boots are not his but have been attached to the front of the pillory for added effect. (Courtesy of Allen Weitzel.)

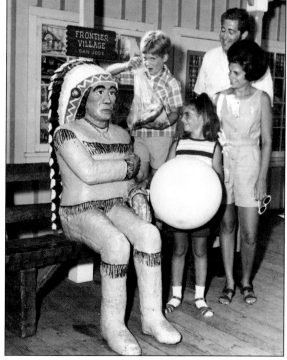

The wooden Indian sitting on a bench in front of the General Store was another great photo opportunity. Here, a family poses next to the figure. The boy is showing off the trout he caught at the Rainbow Falls Fishing Pond. (Courtesy of Allen Weitzel.)

19

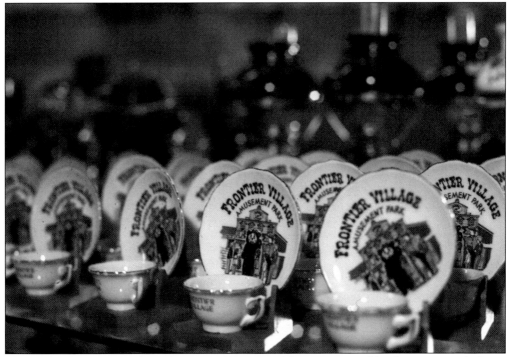

The General Store carried a wide range of Frontier Village souvenirs like these cups and plates.

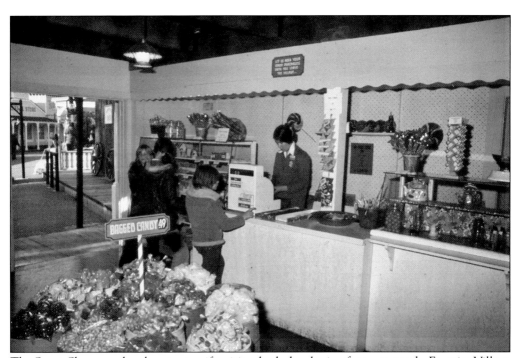

The Sweet Shop was the place to stop if a visitor had a hankering for some candy. Frontier Village shops could be an exciting place to work since they were sometimes robbed by a Frontier Village outlaw, leading to an armed confrontation with the marshal.

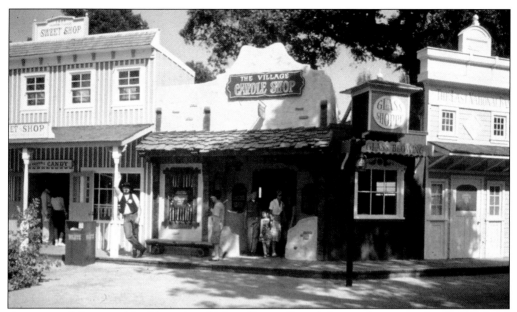

A variety of shops and buildings lined Main Street. From left to right are the Sweet Shop, the Village Candle Shop, the Glass Shoppe, and the Last National Bank. The Last National Bank was often used as backdrop for robberies and gunfights.

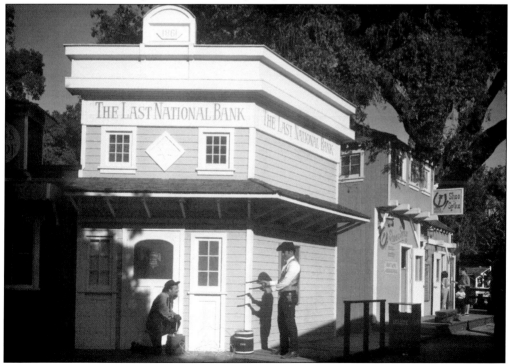

Marshal Clyde catches outlaw Wild Bill Kelsey trying to blow up the Last National Bank. It is good to know that if Wild Bill had accidently hurt himself, the park's first-aid station was located inside the bank. Just down the street next to the bank is the Shoe & Spike, which served darn good grub. It was famous for its hamburger and fries served in a unique paper "saddlebag."

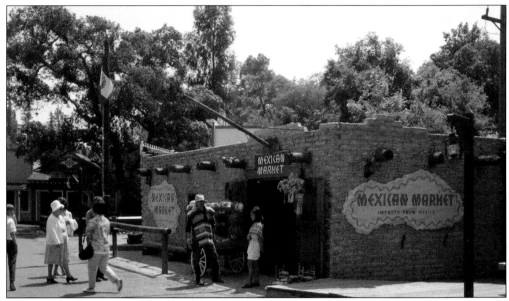

"Dakota the Outlaw," Randy Mitchell, keeps a wary eye on guests walking past the Mexican Market. This building originally housed the Cantina Murieta Mexican Restaurant. In 1969, it became the Mexican Market, which offered goods and curios imported from Mexico. A few years later, it was converted back into the Cantina Murieta.

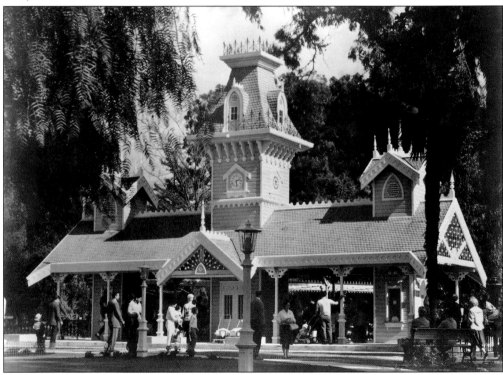

The picturesque Frontier Village Train Station was next to Central Square. The Victorian-style station was built at a cost of $40,000. Visitors could board the Frontier Village & Southern Pacific Railroad train here. (Courtesy of Allen Weitzel.)

Three

RIDES AND ATTRACTIONS

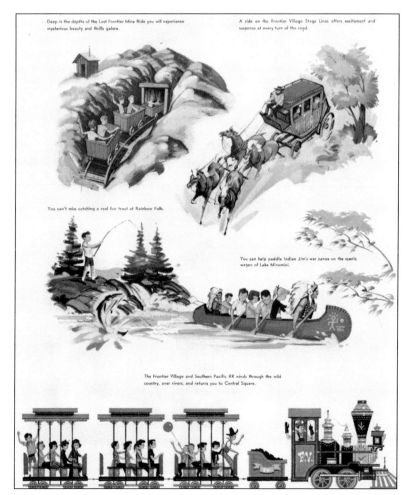

Deep in the depths of the Lost Frontier Mine Ride you will experience mysterious beauty and thrills galore.

A ride on the Frontier Village Stage Lines offers excitement and suspense at every turn of the road.

You can't miss catching a real live trout at Rainbow Falls.

You can help paddle Indian Jim's war canoe on the scenic waters of Lake Minomini.

The Frontier Village and Southern Pacific RR winds through the wild country, over rivers, and returns you to Central Square.

People came to Frontier Village not just to walk Main Street and shop, but also to ride the rides and see the attractions. Frontier Village opened with the Western-themed rides shown in this early brochure, but each year new rides or attractions were added.

The Frontier Village Stagecoaches were made by the Dells Fargo Company in Neillsville, Wisconsin. They were reproductions of the famous Concord stagecoach, based on the measurements of an actual Concord stagecoach in a Chicago museum. The original plans were slightly modified to allow more passenger capacity and incorporate some safety features. Frontier Village purchased two stagecoaches at a cost of $10,000 per coach. Each stagecoach weighed 2,800 pounds and was pulled by four horses originally purchased in Canada. The stagecoach would take passengers on dusty roads through the Frontier Village badlands, the part of the former Hayes Estate gardens that was still undeveloped.

Stagecoach driver Len Johnson sits in a posed shot with a couple of young passengers; the boy has his hands on the wooden braking lever. Johnson would be sitting in this spot if he were actually going to drive the stagecoach. He was the manager of the stagecoach and burro rides and learned livestock handling from his father, who rented trained horses to Hollywood movie studios.

Passengers needed to use a boarding ladder to reach the top of the stagecoach, which was where most passengers preferred to sit. On a busy day, the stagecoaches could handle up to 900 passengers. On such a day, the horse teams would be changed every two hours, a 30-minute process. The stagecoach ride was so authentic, some passengers complained about the hard seats and rough ride.

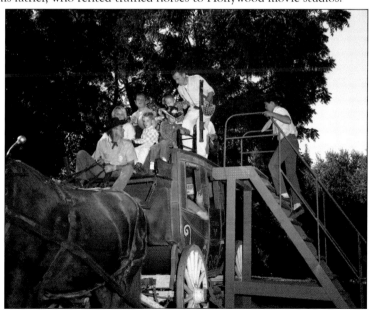

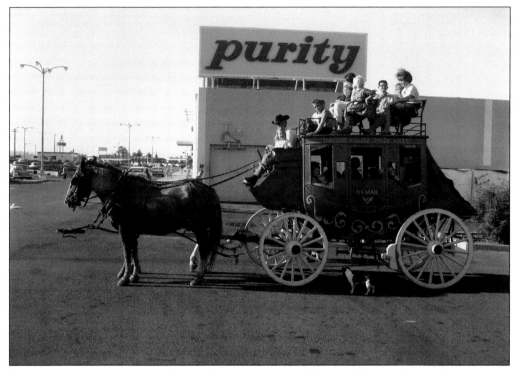

The stagecoach was a perfect publicity vehicle for Frontier Village and thus made special appearances at businesses and events. Here, a stagecoach provides free rides at the Purity Supermarket in Westgate Shopping Center at Saratoga and Campbell Avenues. The October 1963 appearance was in celebration of Westgate's second anniversary.

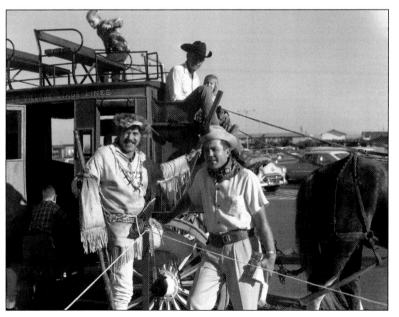

At the Westgate event, the stagecoach is joined by Frontier Village's own mountain man, Indian Jim (left). The man standing next to Indian Jim is unidentified but may be the publicity agent for the shopping center. He is not a Frontier Village employee since Village gunfighters always wore long-sleeved shirts.

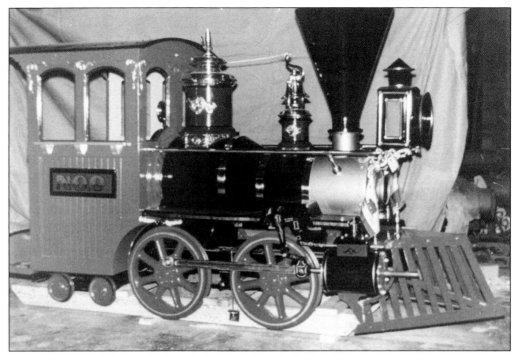

The newly arrived Frontier Village & Southern Pacific Railroad engine rests on its delivery pallet. The engine was a scaled-down version of an 1850 Diamond Stack locomotive manufactured by Arrow Development Company of Mountain View. The 22-inch steel wheels were for show only and did not actually drive the locomotive. (Courtesy of the Tim Stephens collection.)

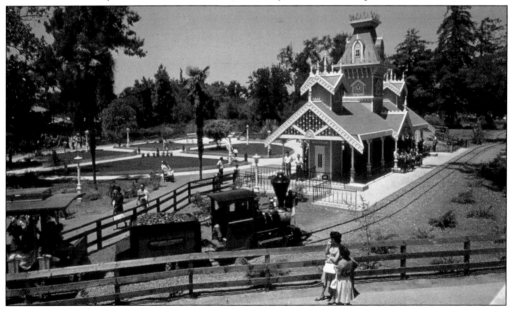

The Frontier Village train approaches the Victorian train station. The locomotive housed the operator and controls but little else. The engine, drive train, brakes, and electrical system were actually housed in the coal tender behind the locomotive. Power was provided by a six-cylinder, air-cooled Corvair engine, which tended to overheat on warm days.

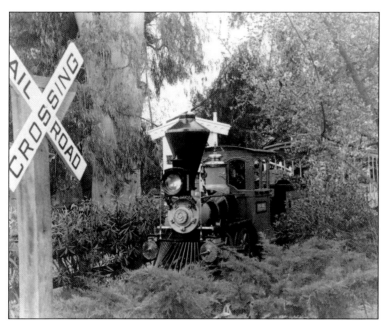

The Frontier Village train nears a railroad crossing on its way back to the train station. The railroad was one of the original rides in place when the park opened in 1961. It was then known as the Frontier Village & Southern Pacific Railroad. When the park was purchased by Rio Grande Industries in 1973, the name was changed to the Frontier Village & Rio Grande Railroad.

Passengers rode in five open-air observation cars with slatted seats. The train ran on 30-gauge rails for one mile through Frontier Village and around the perimeter badlands of the park. During the trip, passengers would listen to the humorous commentary of engineer Casey Jones as he pointed out sights, warned of potential hazards and dangers, and related a few tall tales.

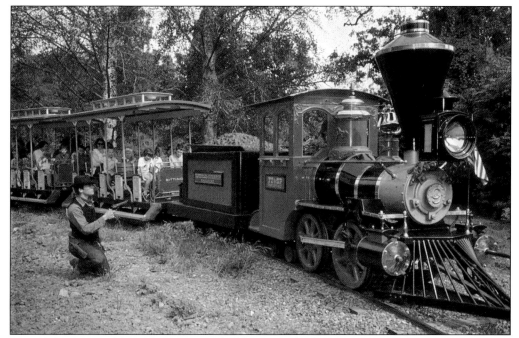

One of the potential hazards was a train holdup in the badlands. Here, an outlaw (Curt Daniels) has stopped the train at gunpoint. The outlaw would check the passengers for valuables before allowing the train to proceed. If the marshal happened to be aboard the train, a gunfight would result. After the outlaw had been vanquished, the train would proceed.

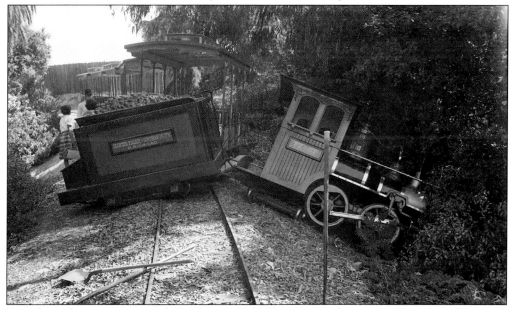

Some hazards were not scripted. On August 17, 1965, two juveniles scattered boards and tree bark on the track, causing the train to derail. Train engineer Terry Peterson and his eight passengers were not hurt, and the train was soon back in operation. After the park closed, the train and cars were sold to the owner of Burke Junction, a Western-themed shopping area in Cameron Park, California.

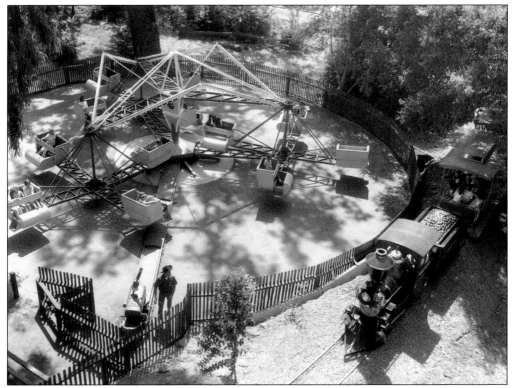

The Frontier Village train passes by the Stampede ride operated by Ron Stock. The Stampede was added to the park in 1966. It was a spinning ride manufactured by the Eli Bridge Company. It is often found in amusement parks and carnivals and is usually called the Scrambler. The Stampede was purchased used from West Coast Shows and refurbished before it was opened. (Courtesy of the Tim Stephens collection.)

Members of the School Safety Patrol pose in one of the Stampede cars while on an outing to the park. Despite the grimaces, the car is not moving, and the latching bolt hangs loose. Once the ride begins spinning, the young man clutching his hat will soon discover that, due to centrifugal force and the fact he is on the outside end of the car, he will be squished by the other two riders. (Courtesy of Allen Weitzel.)

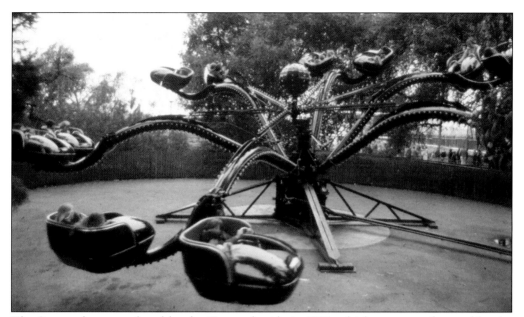

The Stampede was replaced by the Tarantula ride in 1975, which was manufactured by the Eyerly Aircraft Company in Salem, Oregon, and is often called the Octopus or Spider. Frontier Village park designer Laurie Hollings once toyed with the idea of placing a spider head with two large eyes on the round center piece to create a ride that was both scary to look at and exciting to experience.

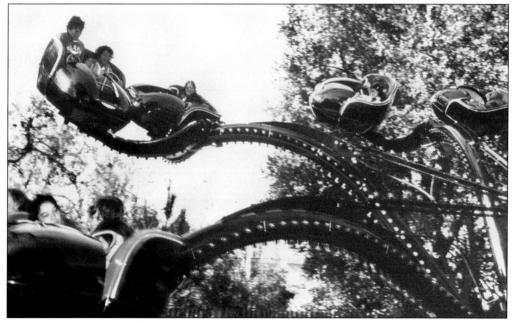

In the 1930s, the Eyerly Aircraft Company produced a ground-based flight simulator that proved more popular as an amusement park ride than as a pilot trainer. Business owner Lee Eyerly used that experience to engineer rides like the Tarantula. Each car rotated independently on the end of arms moving up and down while the entire ride spun, giving sensations of both weightlessness and centrifugal force.

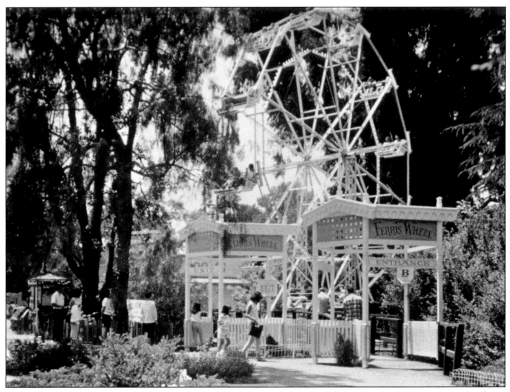

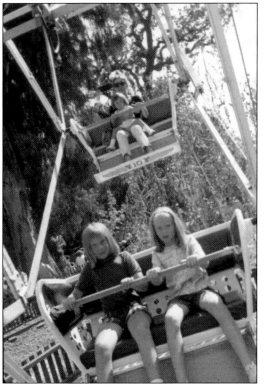

Frontier Village opened its Ferris Wheel in 1965. It was a classic No. 5 Big Eli Wheel, manufactured by the Eli Bridge Company. The Ferris Wheel was 42 feet tall and turned at 6.25 revolutions per minute. It carried 12 seats that could accommodate up to three persons in each. The wheel was turned by a cable drive powered by an electric motor. The ride was positioned among trees, and the nearby tree branches rushing past gave the illusion the wheel was spinning much faster than it really was. The ride required a skilled operator who could load and unload the ride in such a way to keep the wheel balanced.

The Ferris Wheel was the site of two attempts to set a world's record for endurance riding in a Ferris Wheel. In July 1965, nineteen-year-old Jim Bakich set a record of 14 days, which was broken a year later by a Honolulu disc jockey. In July 1978, seventeen-year-old Rena Clark (left) and twenty-one-year-old Jeff Block attempted to set a new endurance record. They were each allowed a five-minute break off of the wheel every hour, which they could save up and use to take a longer break to do things like use the bathroom, take a shower, or exercise. Their meals were supplied by a dietician, but eating while the wheel was in motion could be a challenge. Clark recalls that as the wheel was revolving, the steak she was eating flew off her plate and into the park. To pass the time, Clark had a telephone installed in her Ferris Wheel car, while Block had a copy of the *San Jose Mercury* delivered to the wheel every morning. Clark and Block rode the Ferris Wheel for 37 days, breaking the previous record of 29 days.

The Frontier Village Merry-Go-Round was a big hit with young and old. It was one of the original rides when the park first opened. The Merry-Go-Round was purchased from a park in Washington State. It was manufactured sometime in the 1920s by the Allen Herschell Company, located near Buffalo, New York. The Merry-Go-Round held 36 horses lined three abreast, as well as two chariots. When the park closed, the Merry-Go-Round found a new home at Santa's Village in Skyforest near Lake Arrowhead in Southern California. When Santa's Village closed in 1998, the Merry-Go-Round was acquired by a private individual.

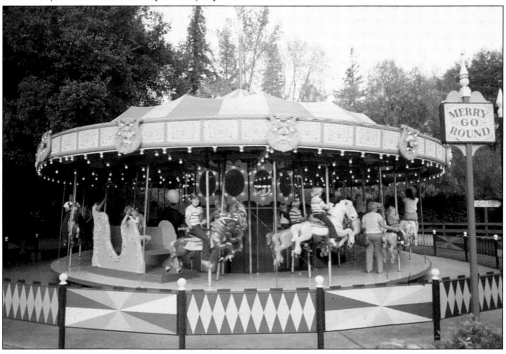

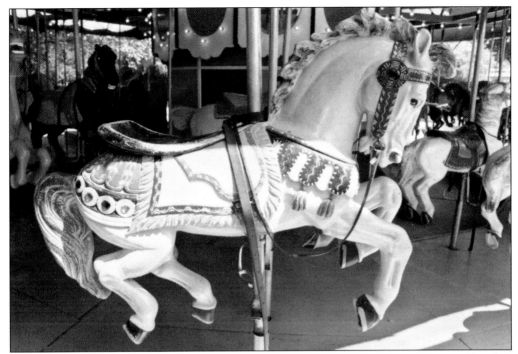

All of the horses were originally carved by hand. At some point, they were given a fiberglass coating, probably in an effort to protect them from the high usage they received. (Courtesy of Allen Weitzel.)

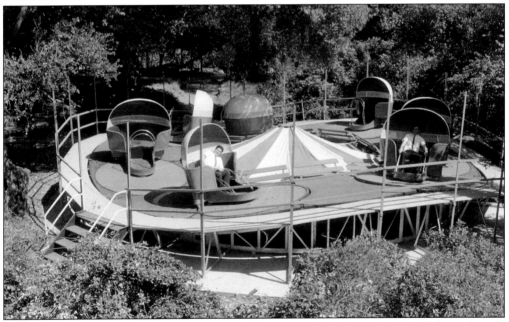

At Frontier Village, the Tilt-A-Whirl ride was known as the Sidewinder. The Sidewinder was purchased new from Sellner Manufacturing in December 1967 and opened for the 1968 season. Giving the Sidewinder a whirl here is public relations/sales director Frank Sanchez (left) and food services director Dick Bradford.

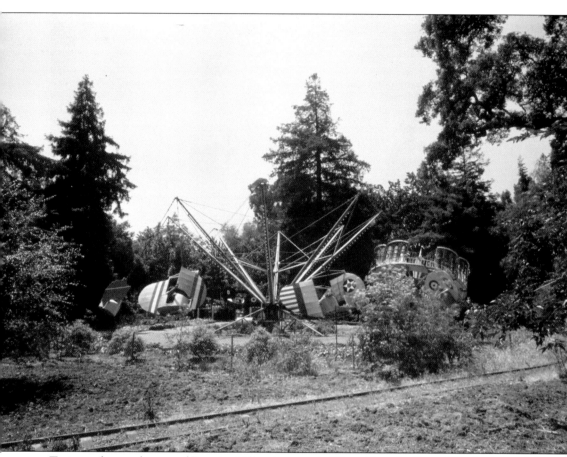

Train tracks pass by two of Frontier Village's more thrilling rides: the Round-Up (right) and the Spirit of Kitty Hawk. The Spirit of Kitty Hawk was a Bisch-Rocco Flying Scooter bought from the Santa Cruz Boardwalk and installed in the fall of 1971. The tub-like cars were suspended from cables attached to metal beams radiating from a central hub. There was a fixed sail at the rear of the tub and a movable sail at the front. As the ride spun, it was possible to move the front sail like a rudder and either lose or gain as much as 15 to 20 feet of elevation. For those less adventurous, just holding the front sail steady created a gentle family ride. Riding the Kitty Hawk was the perfect way to cool off on a hot summer day.

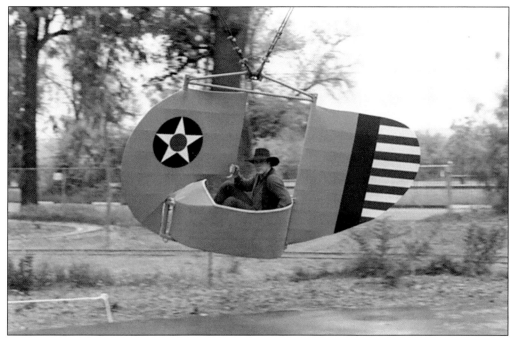

Park employee Bill Perry is seen above giving the Spirit of Kitty Hawk a test run before the park opens. The paint scheme on the sails was the idea of park designer Laurie Hollings. The symbols pay tribute to historical civilian and military aircraft from aviation's early history. Among the planes honored were the American Stearman PT-17 (above) and the French Neiuport (below). Riders of flying scooters at other amusement parks discovered that using the front sail to cause sudden changes in elevation would cause the cables holding the scooter to make a snapping sound. This was not a problem at Frontier Village, as the Spirit of Kitty Hawk ran at a slower speed, which was more suitable for kids and families. (Above, courtesy of Allen Weitzel.)

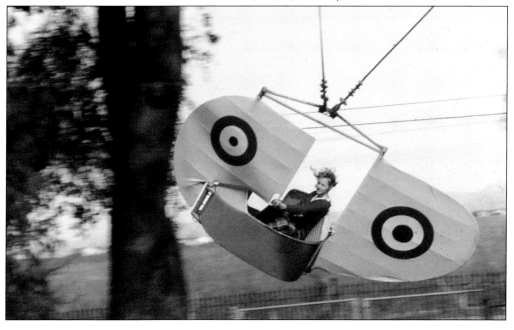

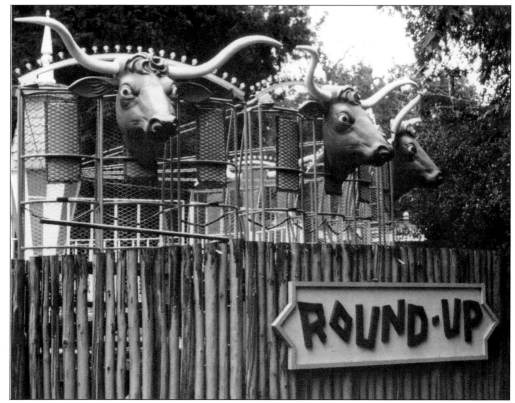

The Round-Up opened in 1972 and quickly became one of the more popular rides in the park. It was a spinning ride manufactured by the Frank Hrubetz Company. A spinning platform rose into the air at an angle, using centrifugal force to press riders against the padded walls. In keeping with the Old West theme, the ride was decorated with the heads of long-horned cattle.

Antique Autos was one of the original rides when Frontier Village first opened. The autos were 3/5-scale replicas of the Maxwell and 1915 Ford Model T. The fiberglass bodies were manufactured by the Arrow Development Company in Mountain View. This early publicity shot shows a woman and girl driving a Maxwell past the Frontier Village Train Station. (Courtesy of Allen Weitzel.)

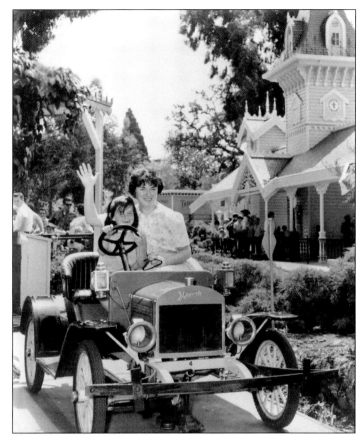

After the ride opened, it became apparent that two children did not want to ride in the same car because only one could steer. To keep two kids happy in the same car, a second steering wheel was added to each auto.

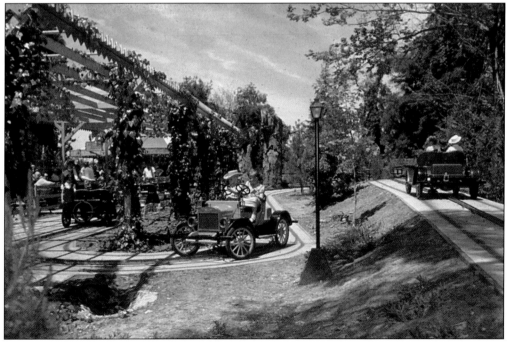

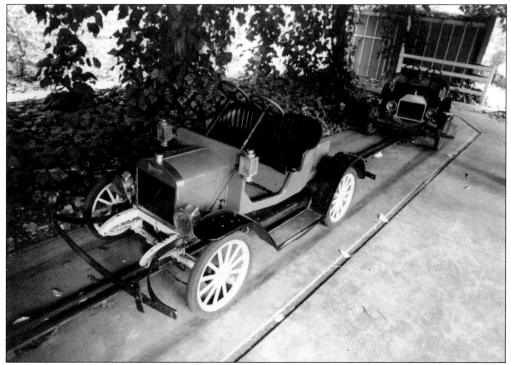

The cars were moved by an electric motor powered by current from the metal rail below the car; the rail also kept the car on course. Each car had two steering wheels so there would be no argument over who got to drive, but neither steering wheel actually worked, as the car would only go where the metal rail took it.

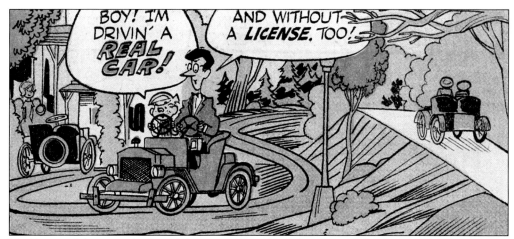

No, Dennis did not need a driver's license to drive his father around the Antique Autos course in this panel from "The Park Lark"—nor did anybody else! On a busy day, a maximum of eight autos could be on the course at the same time. (*Dennis the Menace* ® used courtesy of Hank Ketcham Enterprises, Inc. and © North America Syndicate.)

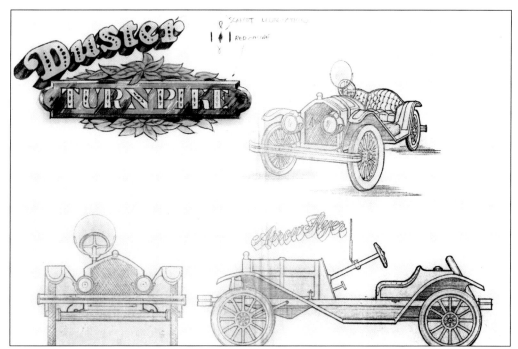

Antique Autos proved so popular that a larger capacity auto ride was opened in 1975. The Duster Turnpike featured a mile-long, double-lane course with a bridge and underpass designed by Laurie Hollings. Modeled after autos built around 1910, the 32 Arrow Flyers were manufactured by the Arrow Development Company in Mountain View. Antique Autos still appealed to younger drivers, so it continued to operate as well.

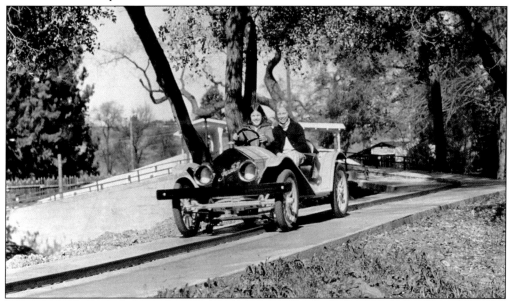

The Arrow Flyer more closely resembled a real car than the Model Ts and Maxwells of Antique Autos. The vehicle was powered by a gasoline engine and had one steering wheel that actually worked in a limited way. The car could be driven from side to side but not very far from the metal strip in the middle of the road that kept it on course.

Ore carts line up outside the Lost Frontier Mine, ready to transport brave visitors into the dark depths of the haunted mine (above). The dark ride was designed by Laurie Hollings and manufactured by Arrow Development Company. Ore carts wound their way through a subterranean wonderland of animation, special effects, and sounds illuminated by fluorescent and blacklights. At times, the carts seemed to be about to crash into a wall or be buried by falling boulders. At other times, the cart would peacefully meander among waterfalls, glowing stalactites, and bubbling sulfur pots (below). (Above, courtesy of Allen Weitzel; below, the Tim Stephens collection.)

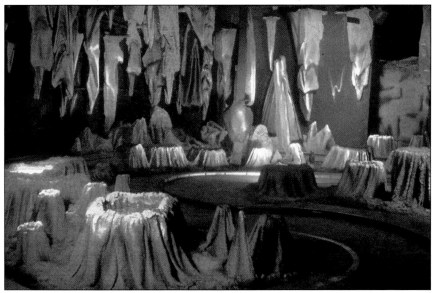

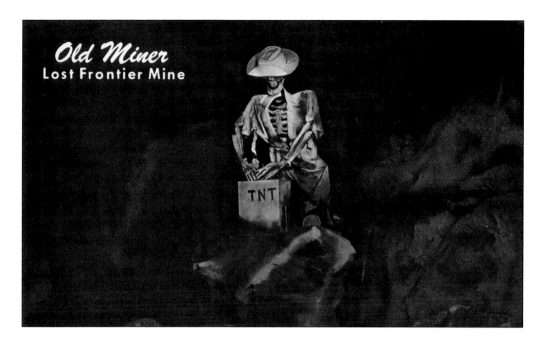

Old Miner
Lost Frontier Mine

Since the mine was haunted, it was no surprise visitors encountered the skeletons of long-lost miners, including the old miner who was about to ignite a box of TNT (above). The resulting explosion and flash of bright light never failed to startle riders in the ore carts (below). (Above, courtesy of the Sourisseau Academy, San Jose State University; below, the Tim Stephens collection.)

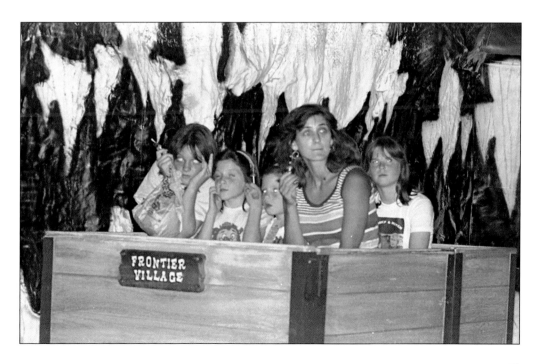

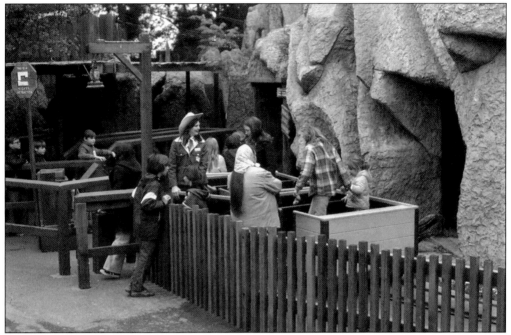

Assisted by ride operator Cheryl (McCandless) Fallstead, guests alight from the ore carts, relieved to be back outside in the real world. But another unexpected surprise awaited them at the end of the ride. When the ore carts came to a halt, the exit door of the cart automatically popped open. This startled some people as much as some of the special effects they had just experienced inside the mine.

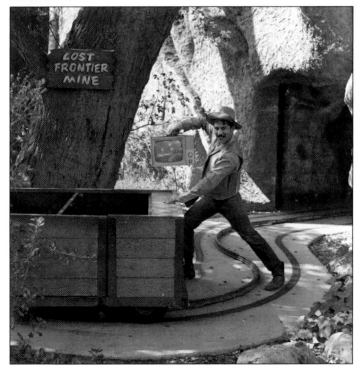

A miner discovers a bargain TV at the Lost Frontier Mine. This was part of an advertising shoot for Furniture Mart. In 1970, the ride was updated with new effects and animations and renamed the Lost Dutchman Mine. (Photograph by Del Carlo, courtesy of the Sourisseau Academy, San Jose State University.)

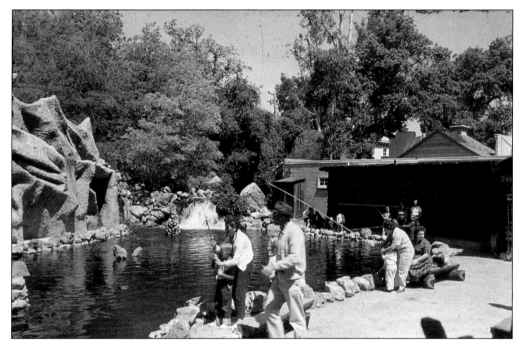

The Rainbow Falls Fishing Pond was one of the busiest fishing ponds in Northern California, holding 8,000 to 10,000 rainbow trout in its 180,000-gallon capacity. The water was kept at a constant temperature of 55 to 60 degrees. The trout were purchased from the Mt. Lassen Trout Farm in Red Bluff. The number of fish caught annually in the pond could exceed 100,000.

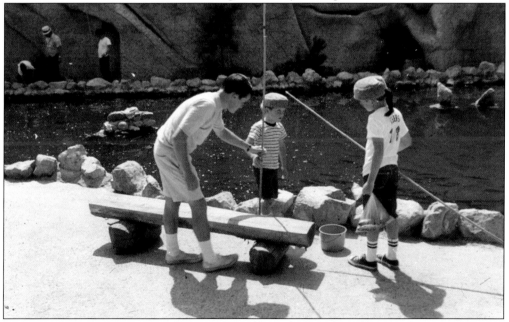

No fishing license was needed, and the park would supply the pole and bait. Park employees would bait the pole, remove fish from the pole, and clean and bag the fish. The cost depended on the size of the fish; trout under 6 inches or over 14 inches were free. The largest trout ever found at the pond measured 23 inches. It was netted in the pond a few days before the park closed.

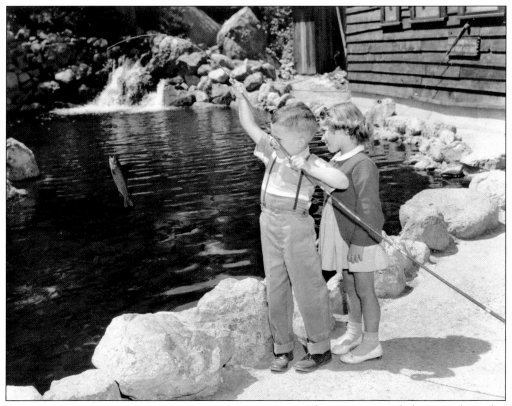

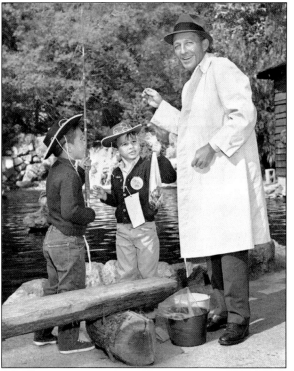

The trout responded so eagerly to the bait that visitors often asked if the fish were being starved. Quite the opposite was true: the trout were fed regularly, turning them into gluttons who would quickly take the hook and bait once it was offered to them. (Courtesy of Allen Weitzel.)

Nathaniel Crosby shows his father, Bing Crosby, the trout he caught at Rainbow Falls while older brother Gary looks on. The Crosby family and friends visited the park on October 26, 1964, to celebrate Nathaniel's third birthday. The group later enjoyed a catered birthday lunch in the Silver Dollar Saloon.

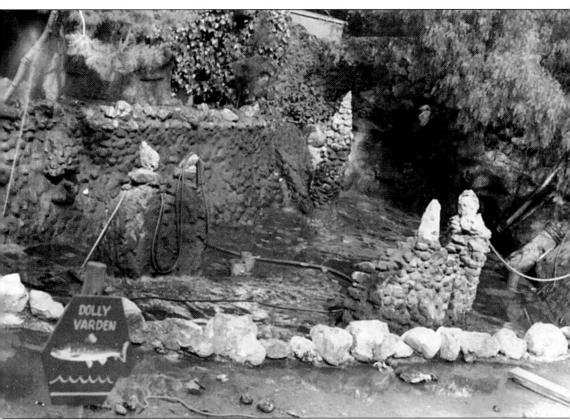

The pond measured 120 feet by 45 feet with a depth of 12 feet. The true size became clear on those rare occasions when the pond had to be completely drained. Algae was a continual problem, and staff sometimes had to scrape the sides daily. During the off-season, the pond might be partially drained to permit a more thorough removal of algae. The pond was entirely drained only when there was a serious problem, like repairs to equipment that could not be made unless the pond was completely empty. Even during the final season, Frontier Village management insisted the pond be kept well stocked until the very day the park closed. After the park closed, the remaining trout were netted and returned to the Mt. Lassen Trout Farm. The pond was stocked with rainbow trout, but Frontier Village management tried to educate visitors by putting signs around the pond with other species of fish, including the Dolly Varden. (Courtesy of Allen Weitzel.)

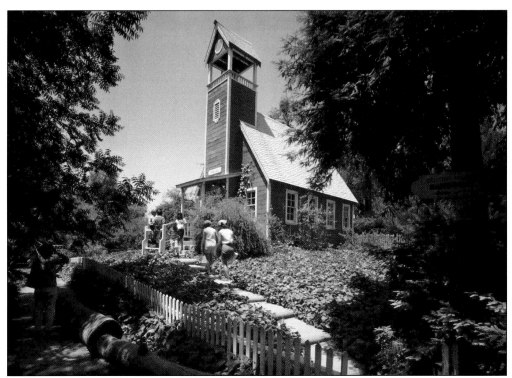

The one-room schoolhouse opened in the 1964. The original plan was to have wax figures of the teacher and students sitting at their desks. When that could not be done, park employee Bill Kelsey volunteered to take over the schoolhouse project. Kelsey furnished the room as if the students had just left for recess, using materials already acquired by Frontier Village as well as from local antique stores. The room contained old-fashioned desks with inkwells, covered with McGuffey readers, pencil boxes, slates, and other typical school items. Kelsey recorded a narrative tape in an old man's voice, which was played for visitors touring the schoolhouse. The bell in the tower bell came from an old school in Almaden. It could be rung with a rope, but overuse eventually broke the mechanism beyond repair.

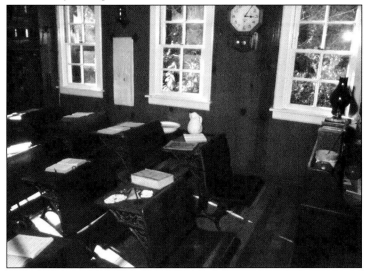

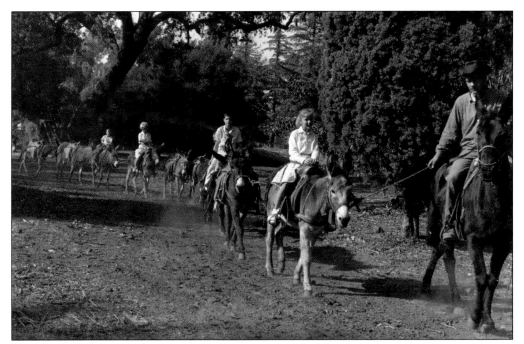

The Burro Pack Train was a slow-paced way to see the wild badlands of the park, led by a park employee on a horse. When the burros were originally obtained from Mexico, it turned out some of them were pregnant, which helped increase the herd.

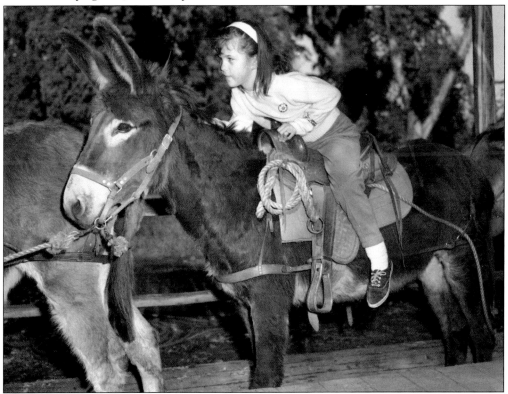

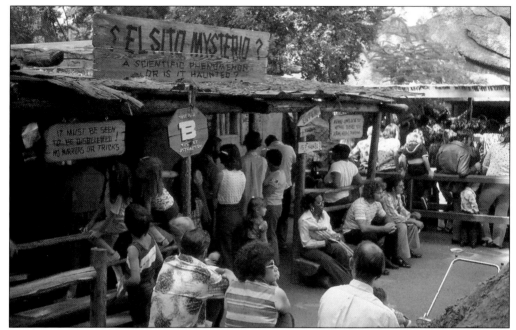

Some unknown force would draw people to El Sito Mysterio. Legend said that a meteorite buried beneath this site caused fluctuations in the local magnetic field. The effects were first discovered by Juarez, an old gardener on the Hayes Estate who had warned workmen not to build on this space.

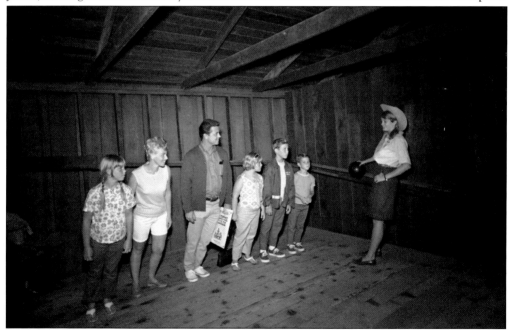

Despite being carefully constructed with "elusibolts" and "tricenetometer brackets," the laws of gravity no longer worked in El Sito Mysterio. A Frontier Village guide explains this to the Williams family in August 1968, demonstrating how a bowling ball would roll uphill. One visitor claimed her watch gained 20 minutes while inside, prompting management to consider posting a warning sign about possible adverse effects on electronic gadgets.

A game of pool is almost impossible when the players can't stand straight and the balls don't go where they should. Water would also run uphill, and brooms stood erect by themselves. All this was overseen by the knowing image of Juarez on the left wall, an image whose eyes seemed to follow one throughout the room.

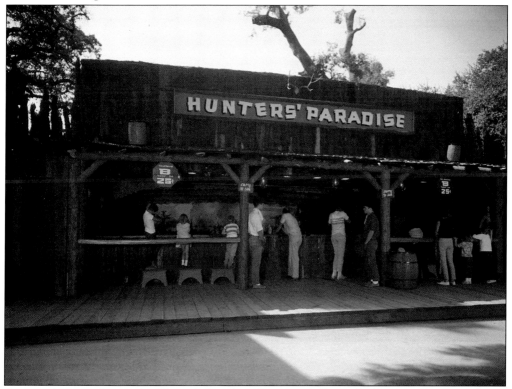

Aspiring hunters throng the Hunter's Paradise Shooting Gallery, which opened on Front Street in 1965. It was designed by Laurie Hollings and built at a cost of $30,000.

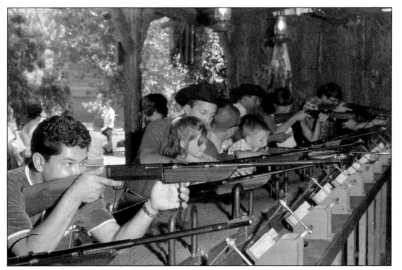

The shooting gallery mounted 12 high-pressure air rifles. The .22-caliber rifles shot round lead pellets and held 14 rounds. All the reloading was done by three shooting gallery supervisors who were always on site.

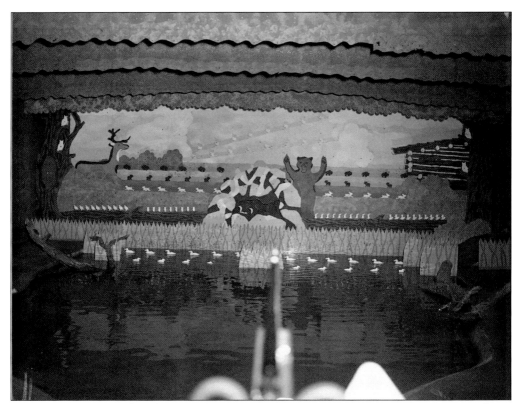

Targets were positioned 30 feet away from the shooters. Among the moving targets were flying geese, running rabbits, swimming ducks, quail, moose, owls, buffalo, and a deer. There was also a five-foot-tall grizzly bear with a gong that would clang when shot in the mouth. The damage caused by the lead pellets meant the targets had to be repainted every Sunday night after the park had closed.

Indian Jim's Canoes were paddled on a man-made canal and lake created by removing 25,000 cubic feet of earth. Although the canals held 2.5 million gallons of water, severe seepage problems delayed the full operation of the ride until the spring of 1963.

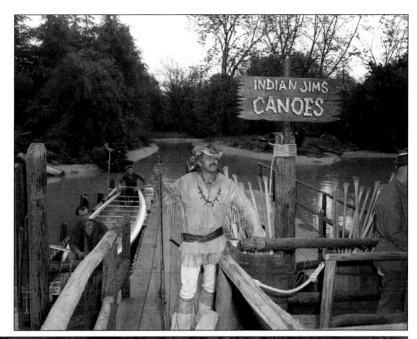

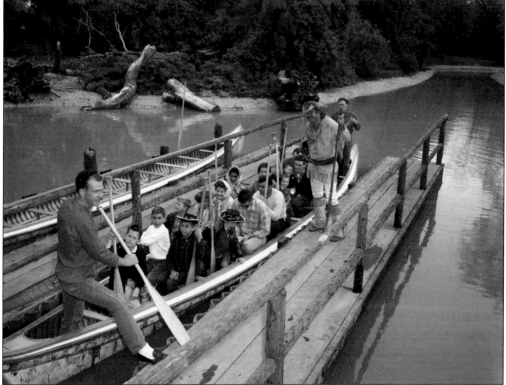

Frontier Village had to go back east to find a company capable of making authentic Indian canoes, which were handmade by the Old Town Canoe Company in Maine. They were built of canvas over a wood frame and cost $1,500 each. They measured 34 feet in length, weighed 800 pounds, and could hold 18 to 22 people. In 1966, the leaky canvas was replaced with fiberglass hulls.

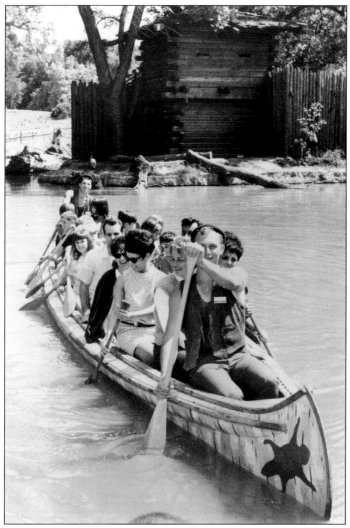

A fully loaded canoe is paddled past Fort Far West (left). Every guest was given a paddle and encouraged to participate in rowing, but it was the responsibility of the two ride operators to ensure the canoe got where it was supposed to go. In this canoe, the operators are Larry ? in the front and Allen Weitzel in the rear. The front operator provided the power stroke and gave instructions and commentary to the guests. The operator in the back provided some power but was primarily responsible for steering. The canoes were the most physically demanding of Frontier Village's rides to operate, especially on warmer days. While visiting the park, Dennis the Menace also attempted to paddle a Frontier Village canoe, creating quite a splash (below). (Below, (*Dennis the Menace* ® used courtesy of Hank Ketcham Enterprises, Inc. and © North America Syndicate.)

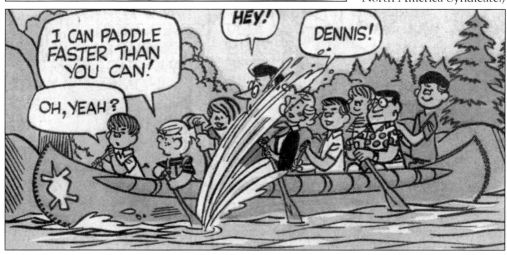

The canoes were often used in publicity shots, such as this photograph taken during Safety Patrol Fun Day in May 1971. In the canoe are, from left to right, (first row) Brian Hupp and Mark Deshetler of Northwood School; (second row) Andre Symons and Tim Case of Henderson School; (third row) safety patrol officer Joe Haslemann and Brigitte Hossay of Valley View School; (fourth row) San Jose mayor-elect Norman Mineta.

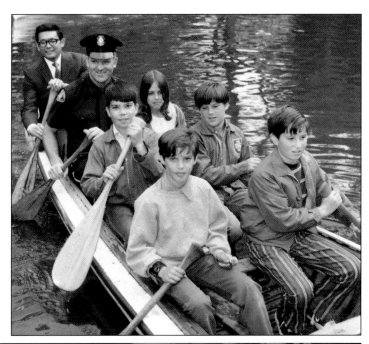

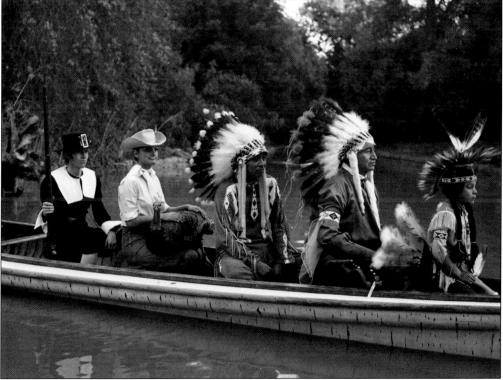

In 1967, Frontier Village celebrated Thanksgiving with a canoe ride for three Indians, a cowgirl (Kim Goozee), a pilgrim (Chuck Lowe), and a turkey. During the Thanksgiving season, employees dressed as pilgrims were on hand to greet visitors. Visitors could register at the Marshal's Office to win one of five free turkeys given away daily.

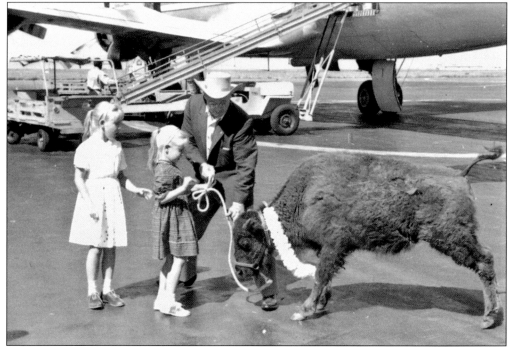

Cimarron was a buffalo calf acquired in 1961. Frontier Village management thought it was important that children visiting the park could see what real buffalo looked like. Cimarron came from the B-Bar-B Ranch in Gillette, Wyoming. He was flown by plane to San Francisco Airport (above) at a time when transporting livestock by air was rare. He was then moved by truck to Frontier Village, where he lived in a pen next to the burro stables. He thrived and grew to an adult, as seen here being admired by Shirley Montgomery (below). After 11 years at Frontier Village, Cimarron was sold to Theodore Skipper of Evergreen Supply, who planned to have him on display in front of his store on Monterey Road. The price was $100, which Frontier Village donated to the Muscular Dystrophy Association. (Below, courtesy of Allen Weitzel.)

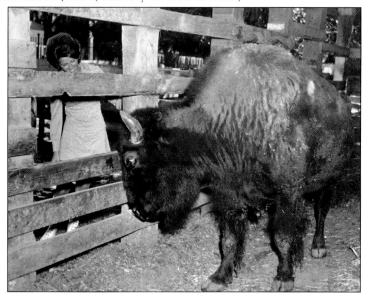

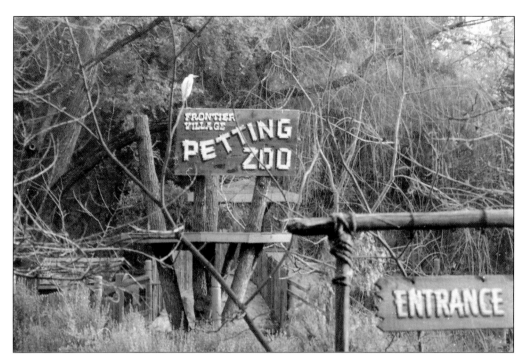

A heron perches on the sign for the Frontier Village Petting Zoo (above), which opened in 1969. The petting zoo was built on a small island that was originally intended to be the location of a haunted house. The petting zoo was renovated and expanded in 1977. Park designer Laurie Hollings thought it would be fun to build a bridge using floating barrels to connect the petting zoo with Indian Island (right). The bridge was exciting to cross, mainly because the barrels kept leaking and the bridge kept sinking. After a series of futile repairs, the bridge was removed. The tower in the background was part of the petting zoo and was erected to give goats a structure to climb. (Both photographs by Marq Lipton, courtesy of the Tim Stephens collection.)

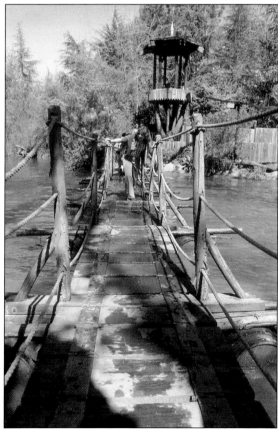

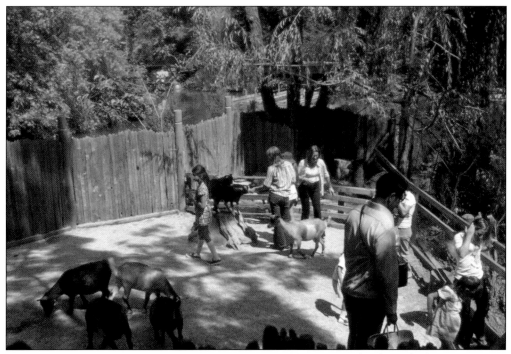

Visitors wander through the goat enclosure in the petting zoo. Among the animals that were available to be seen or petted were goats, chickens, rabbits, burros, sheep, llamas, pigeons, tortoises, peacocks, and peahens.

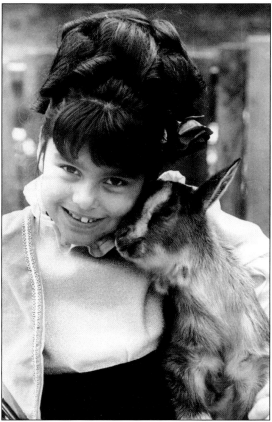

Seven-year-old Debbie Alvarez cuddles with a baby goat. Alvarez was a member of the Hayward Twirlettes, who performed during Hayward Days in March 1971. (Courtesy of Allen Weitzel.)

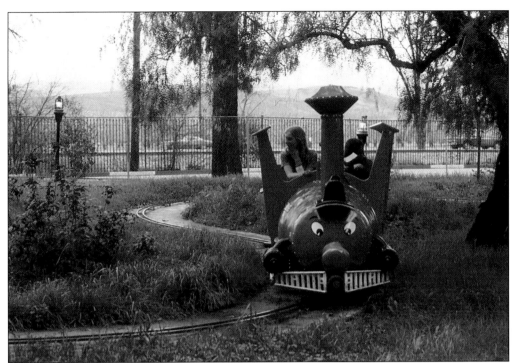

The Old 99 train was a good choice for parents with young kids who wanted a slow and gentle ride. It was added for the 1968 season. Five trains with cartoon faces were powered by electric motors through the short, winding course. The train did not pull any cars, so the riders sat in front, ringing a small bell if they wished. When the park closed, the Old 99 trains were sold to Happy Hollow Zoo.

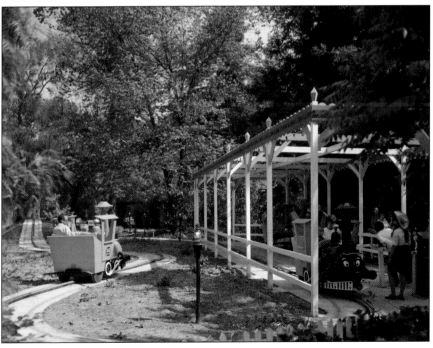

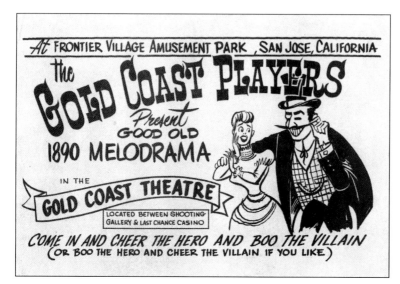

Every weekend, the Gold Coast Players presented old-fashioned melodramas in the Gold Coast Theatre. The 20-minute performance cost 25¢. Hissing, cheering, clapping, and booing during the show were actively encouraged by management.

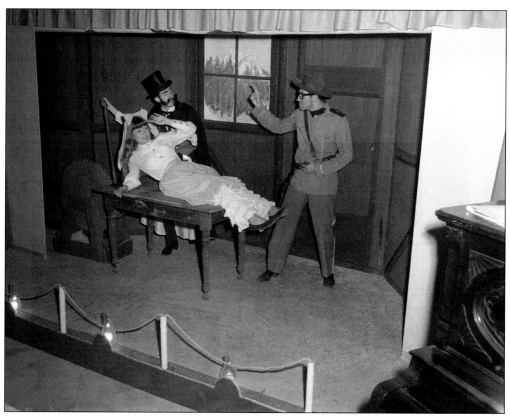

In this photograph, the Gold Coast players present what was called *Melvin of the Mounties* or *Klod of the Klondike*. It was the suspenseful story of dismounted Mountie Melvin Klod (Joel Osborne) and his attempt to save his sweetheart, Prudence Purepenny (Kathy McMullin), from the clutches of the villainous Filthy Floyd (Chuck Lowe). Ironically, a few years later, Chuck Lowe would move from role of villain to that of the Frontier Village marshal.

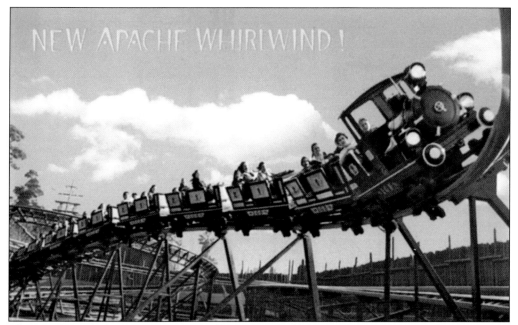

NEW APACHE WHIRLWIND!

The Apache Whirlwind was Frontier Village's first thrill ride. It was purchased for $600,000 from Heinrich Mack Co., a German business known for its innovative coaster rides. In Germany, it was known as the Blauer Enzian (Blue Gentian Flower), but in the United States this type of ride was popularly known as the Runaway Train. Before settling on the name Apache Whirlwind, Frontier Village management considered a number of other names, including the Cannonball Express and the Superchief Express. The ride was dedicated on February 11, 1977. (Above, courtesy of Allen Weitzel.)

The Apache Whirlwind charged through a figure-eight course with steeply banked curves and a 360-degree spiral. Unlike tall coasters, the ride was powered by electricity rather than gravity. The tight course and tracks low to the ground gave the illusion the train was traveling faster than it really was. It would reach a maximum speed of 28 miles per hour as it made two circuits of the track during the three-minute ride. The 10-car train could carry up to 38 people. Since there was no operator on board, two people could sit in the engine cab. (Left, courtesy of Allen Weitzel.)

Four

INDIAN ISLAND

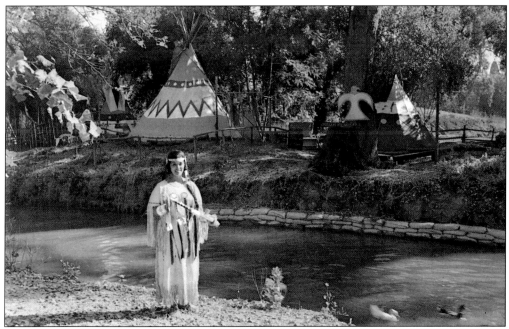

Princess Tenaya stands on the canal bank in front of Indian Island. Behind her are some of the Indian dwellings that were erected on the island. Princess Tenaya was a full-blooded Miwok from the Yosemite area. (Courtesy of the Sourisseau Academy, San Jose State University.)

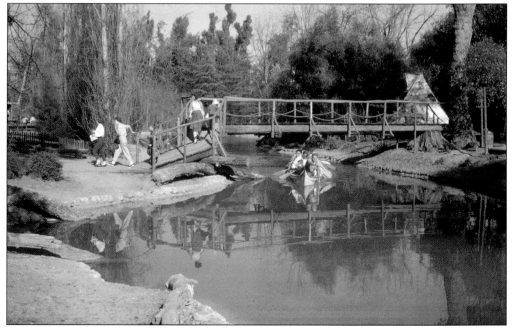

Indian Island was located in Frontier Village's man-made lake. One way to reach the island was by crossing this bridge, under which one of Indian Jim's canoes has just passed. The island could also be reached by a swinging rope bridge suitable for the more adventurous. To the right is one of Indian island's tipis.

At one end of the island stood Fort Far West, a frontier stockade fort with a blockhouse. Children could climb up to the stockade wall and pretend to shoot one of the rifles mounted on swivels protruding through slits in the blockhouse walls.

Mountain man Indian Jim welcomed visitors to Indian Island wearing his wildcat fur hat and carrying his long rifle. Jim is seen here wearing a turquoise necklace and a buckskin outfit he made himself. Indian Jim was probably the most colorful and memorable Frontier Village character. His knowledge of Native American and Western lore was remarkable.

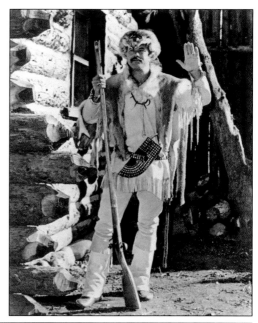

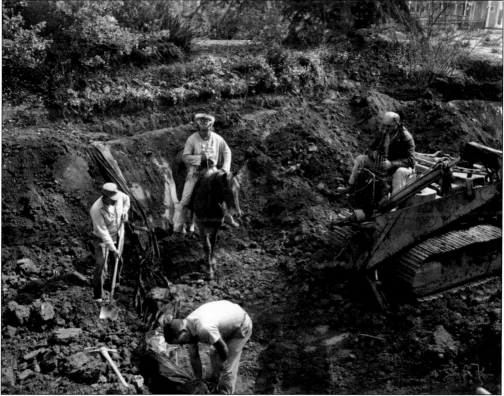

Indian Jim inspects the excavation of one of the waterways that would surround the island. When the waterways were filled, it was discovered much of the water was leaking back into the soil, so the sides and bottom were compacted and sealed with a mixture of clay and plastic. When the leaks continued, the problem was solved by sealing the soil with a layer of concrete.

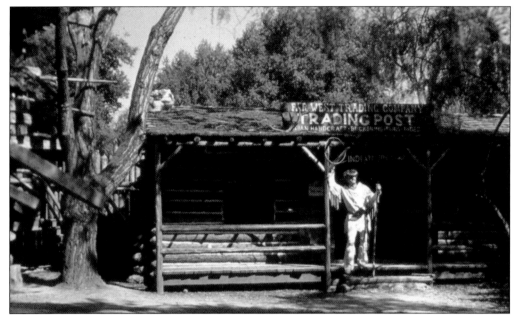

Indian Jim stands in front of the Trading Post in Fort Far West (above). Indian Jim was the proprietor of the Trading Post, which sold Indian goods (below), some of which were made by him. Indian Jim was half Huron, and his father once served as sheriff of San Louis Obispo County. He was involved with Frontier Village from its beginning and stayed with the park until the late 1960s. After leaving Frontier Village, Indian Jim had a business making traditional Native American regalia. He was a teacher, taxidermist, and artist. He did not give his friendship easily, but once he did he was a friend for life.

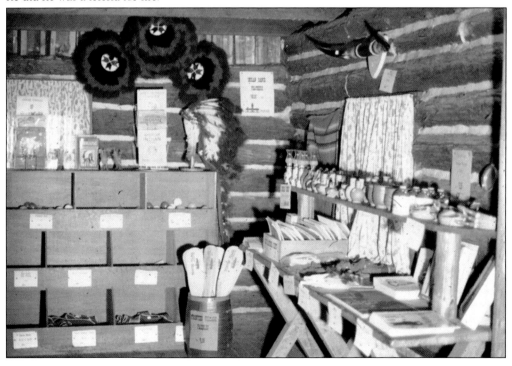

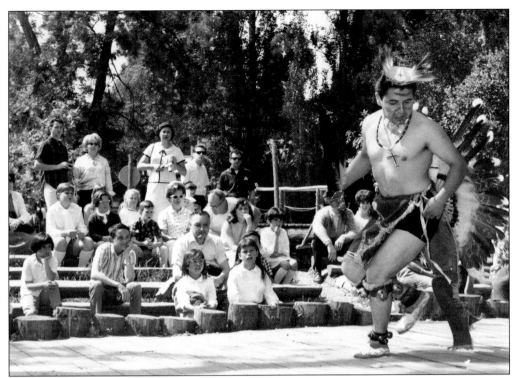

Indian Jim also organized the display of Native American dancing, which took place regularly on the Indian Island Stage. The dances were discontinued after Indian Jim left Frontier Village. (Above, courtesy of Allen Weitzel.)

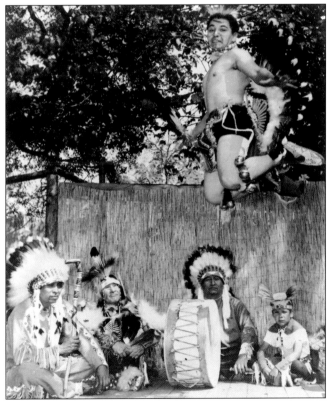

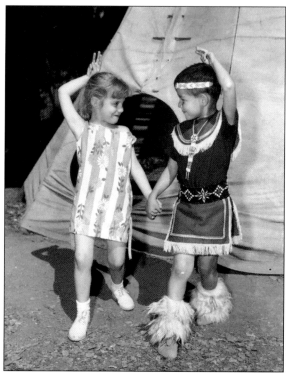

Ronald Poolow (right), a six-year-old full-blooded Kiowa Indian, gives five-year-old Bobbi Judd of San Jose her first lesson in Indian dancing during a Native American powwow held at Frontier Village in May 1964. (Courtesy of Allen Weitzel.)

Before the park opened, Indian Jim helped assemble a couple of tipis that Frontier Village staff had bought but did not know how to put together. He also built additional replicas of Native American dwellings on Indian Island, including a wickiup and hogan.

In the movie *How the West Was Won*, James Stewart played mountain man Linus Rawlings. Here, Stewart meets Frontier Village mountain man Indian Jim and Princess Tenaya during the San Francisco premiere of the movie in February 1963. A week earlier, Indian Jim and Princess Tenaya had set up a tipi for three hours in San Francisco's Union Square to publicize the film's opening.

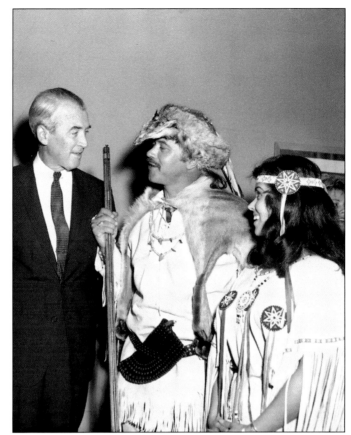

In 1966, Indian Jim expanded the attractions on Indian Island by building an Archery Range.

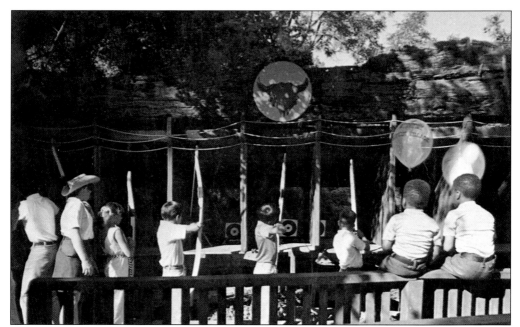

At the Archery Range, kids lined up to shoot a real bow and arrow, overseen by a Frontier Village employee. (Courtesy of the Sourisseau Academy, San Jose State University.)

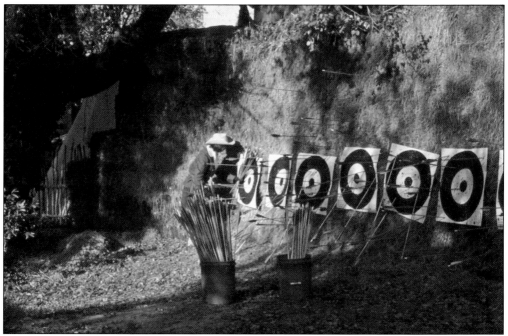

Of course, after all the arrows had been shot, someone had to go out onto the range and retrieve them. Indian Jim said that one of more difficult challenges in setting up the Archery Range was figuring out how the keep the arrows from going through the rear wall.

Five

GOOD GUYS, BAD GUYS, AND FALL GUYS

Every hour, Main Street would ring with gunshots as the marshal would bring justice to another outlaw under the gaze of fascinated spectators. The staged gunfights were a unique part of the Frontier Village experience that visitors would long remember, including a riveted Dennis the Menace (at far left). (*Dennis the Menace* ® used courtesy of Hank Ketcham Enterprises, Inc. and © North America Syndicate.)

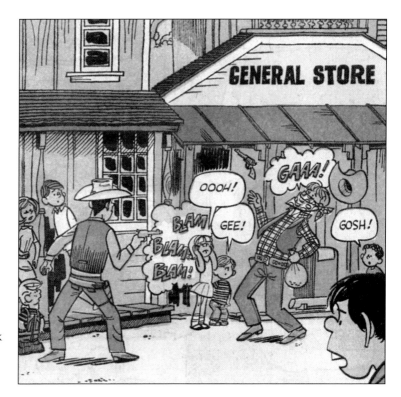

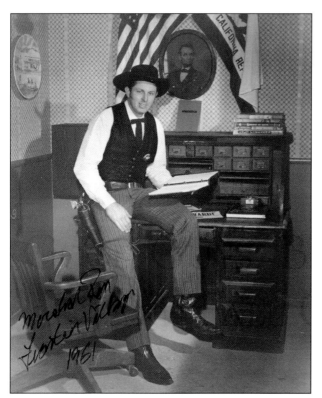

Ron Jabaut poses in the Frontier Village Marshal's Office. A former Palo Alto police officer, Marshal Ron was the first marshal of Frontier Village, hired before the park even opened. When Frontier Village decided to hire a lawman, they used the title marshal rather than sheriff, as it sounded more dignified; they also figured *marshal* would be easier for young mouths to pronounce.

At six feet, four inches, and 215 pounds, Marshal Ron had a commanding presence. A student of Western history, the marshal felt the outfit he wore was unduly influenced by Western shows, then so popular on TV. According to Jabaut, a real marshal would have dressed much more conservatively, as a man in town dressed like this would have been immediately identified as a gambler. (Courtesy of Allen Weitzel.)

Marshal Ron served until August 1963, when he was replaced by Clyde Adamson. This was quite a role reversal for Marshal Clyde, who, before stepping into the marshal's boots, had been playing one of the Frontier Village bad guys, an outlaw named Jake.

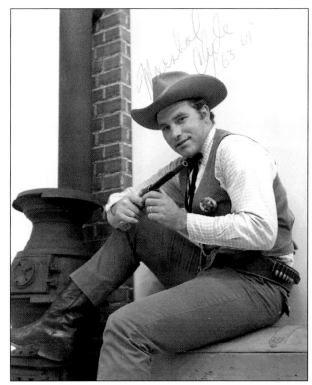

Marshal Clyde shows some young visitors the inside of the Frontier Village Jail. In addition to battling outlaws, the marshal had the real responsibility of keeping park visitors safe and secure. Marshal Clyde was the longest-serving Frontier Village marshal, leaving in September 1969.

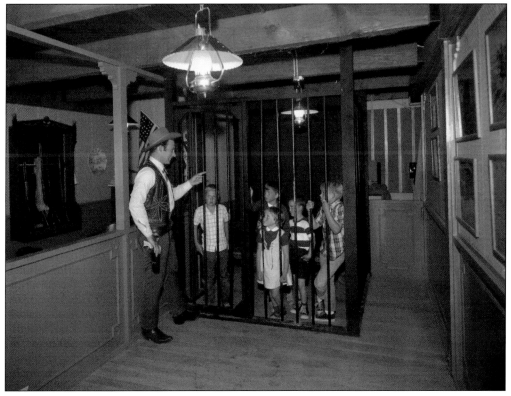

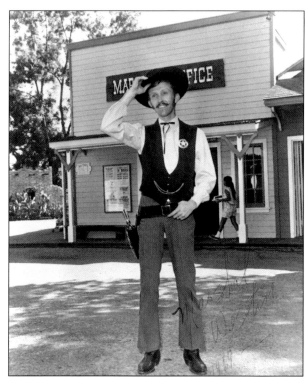

The marshal role was taken over by Chuck Lowe, who had been entertaining Frontier Village visitors for some time as a member of the Village's resident acting troupe, the Gold Coast Players. Rather than be known as Marshal Chuck, he decided to use an old family name and call himself Marshal Westin. After this, all the Frontier Village marshals were known as Marshal Westin.

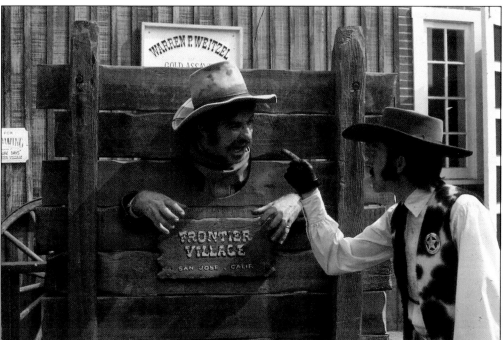

Marshal Westin admonishes outlaw Dakota (Randy Mitchell), who is being punished in the pillory. Marshal Westin was the last of the full-time salaried marshals at Frontier Village. When Chuck Lowe left Frontier Village in the early 1970s, the marshal badge was retired to honor the three full-time marshals: Ron Jabaut, Clyde Adamson, and Chuck Lowe.

Marshal Westin (Mike Hassel) receives assistance from a young volunteer in removing the boots from a fallen outlaw before the waiting undertaker carts the body to Boot Hill. Following the departure of Chuck Lowe, the role of lawman was filled by a series of part-time seasonal employees who wore a deputy marshal badge. (Courtesy of the Tim Stephens collection.)

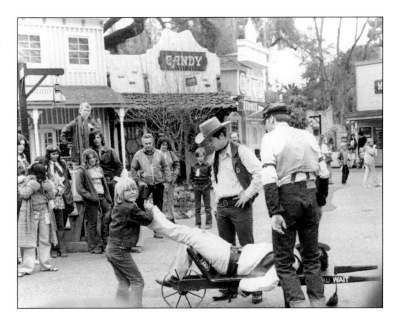

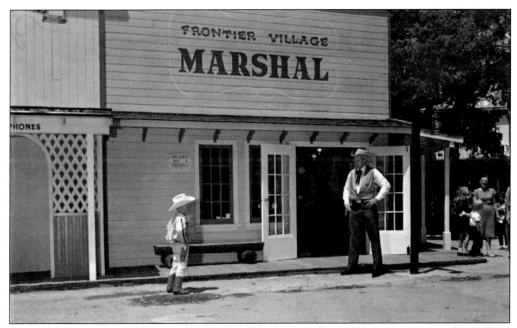

Marshal Ron greets a young cowpoke in front of the Marshal's Office, which was a busy place. Visitors could buy ride tickets, check lost and found, request first aid, or report a problem. The marshal had to deal with the unexpected. Once, Marshal Ron had to organize park employees to rescue a visitor's parakeet that had flown from her shoulder to the top of one of the park's tall oak trees. (Courtesy of the Sourisseau Academy, San Jose State University.)

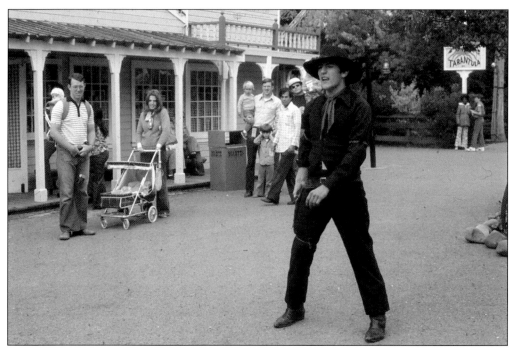

Outlaw Concho (Arnie Perez) strides confidently down Main Street on his way to rob the General Store. He is closely observed by park visitors who know something exciting is about to happen.

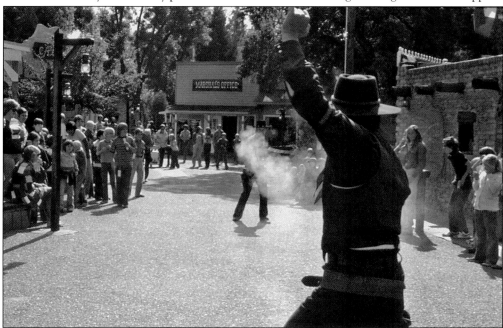

After the robbing the General Store, Concho is confronted by Marshal Westin (Mike Hassel), and a shoot-out takes place. All the gunfights were closely choreographed, and proper timing was important. During one gunfight, an outlaw walking away from the marshal was supposed to take three steps and then turn around and draw on the marshal. When the outlaw failed to turn on cue, the marshal accidently shot him in the back, much to the consternation of the onlookers.

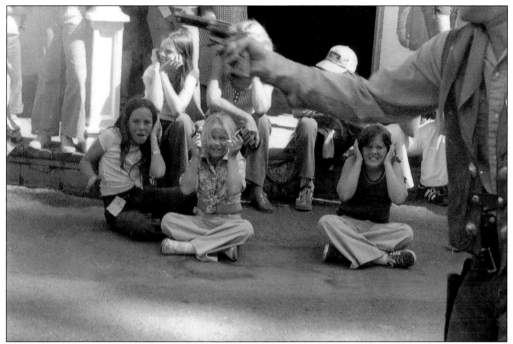

Several spectators react to the noise of the pistols being fired. As the land around Frontier Village was being developed, neighbors started complaining about the noise of the gunfights. They requested a less-powerful charge be used, but the amount of powder used in each blank remained the same. (Photograph by Marq Lipton, courtesy of the Tim Stephens collection.)

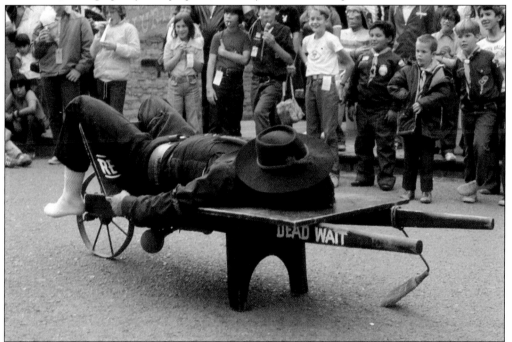

After losing the gunfight with the marshal, Concho lies on the hearse, waiting to be hauled away. His boots have already been removed.

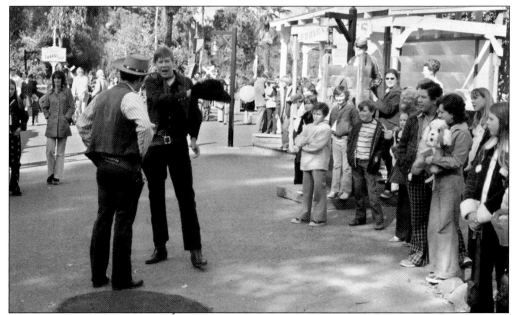

During a high noon gunfight, Utah (Eric Pringle) tries to provoke Marshal Westin (Mike Hassel) by waving his hat at him. Unsuccessful, the outlaw would then pretend to walk away and suddenly turn and draw, forcing the marshal to defend himself. All lawmen and outlaws had to undergo six hours of firearms training before being allowed to perform. In addition, outlaws had to be trained for another three to six hours to learn how to fall without hurting themselves.

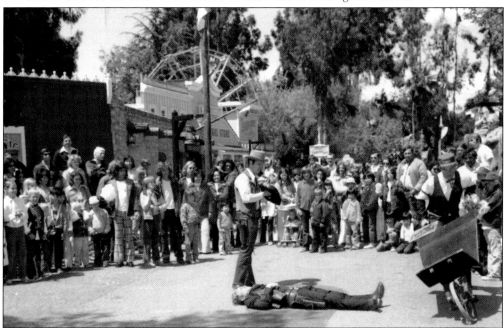

Marshal Westin (Mike Hassel) examines the offending hat, while Utah (Eric Pringle) lies on the ground after failing to outdraw the marshal. Lance the Undertaker (Neil Fallstead) brings up the hearse. The comic antics of the undertaker would lighten the mood after the intensity of the gunfight and prove to the crowd that the outlaw was not really dead.

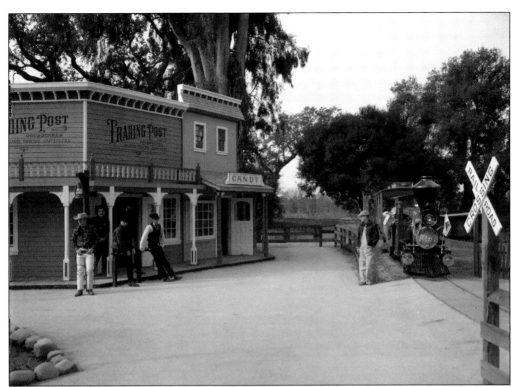

Bad guys could cause trouble in other parts of the village. Here, Frontier Village train engineer Casey Jones nervously eyes a suspicious group of men hanging around the Frontier Village Trading Post. Casey is worried because he knows he has a shipment of gold aboard the train preparing to depart.

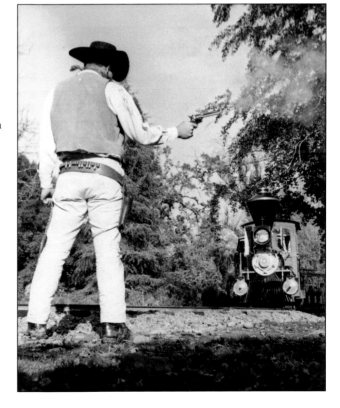

An outlaw fires a warning shot, forcing the Frontier Village train to stop in the middle of the badlands. Hopefully, the marshal is aboard!

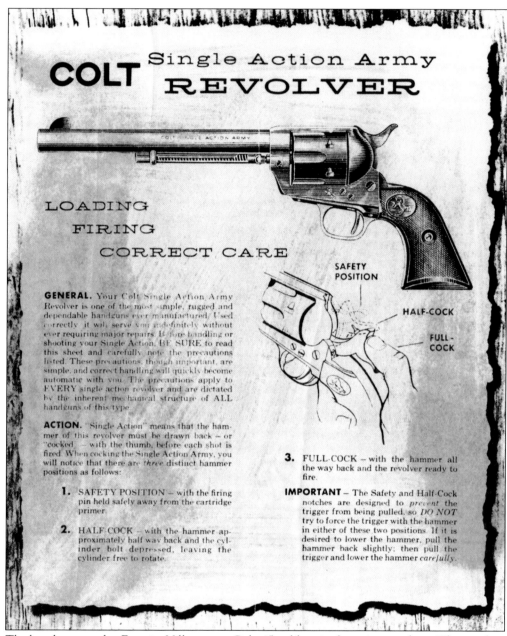

COLT
Single Action Army
REVOLVER

LOADING

FIRING

CORRECT CARE

GENERAL. Your Colt Single Action Army Revolver is one of the most simple, rugged and dependable handguns ever manufactured. Used correctly it will serve you indefinitely without ever requiring major repairs. Before handling or shooting your Single Action, BE SURE to read this sheet and carefully note the precautions listed. These precautions, though important, are simple, and correct handling will quickly become automatic with you. The precautions apply to EVERY single action revolver and are dictated by the inherent mechanical structure of ALL handguns of this type.

ACTION. "Single Action" means that the hammer of this revolver must be drawn back – or "cocked" – with the thumb, before each shot is fired. When cocking the Single Action Army, you will notice that there are *three* distinct hammer positions as follows:

1. SAFETY POSITION – with the firing pin held safely away from the cartridge primer.

2. HALF-COCK – with the hammer approximately half way back and the cylinder bolt depressed, leaving the cylinder free to rotate.

SAFETY POSITION

HALF-COCK

FULL-COCK

3. FULL-COCK – with the hammer all the way back and the revolver ready to fire.

IMPORTANT – The Safety and Half-Cock notches are designed to *prevent* the trigger from being pulled, so *DO NOT* try to force the trigger with the hammer in either of these two positions. If it is desired to lower the hammer, pull the hammer back slightly; then pull the trigger and lower the hammer *carefully*.

The handguns used at Frontier Village were Colt .45-caliber single-action revolvers. The revolver used .45-caliber brass cartridges that the gunfighters would load with black power. This was a live round, with the shell filled with black powder but without a lead bullet on the end. Even shooting blanks, the detonation could shoot a 6- to 12-inch flame from the end of the revolver. Discharging a gun within 5 to 10 feet of a person could cause injury. Gunfighters had to ensure there was sufficient clear space around them before firing their gun. In 1970, the park switched to safer preloaded blanks with flash powder bought from Superior Blanks Company in Los Angeles. The park would fire 15,000 of these blanks every year. This page from the *Frontier Village Employee Weapons Handling Manual* shows the three stages of cocking the weapon.

Wild Bill Kelsey leans against a lamppost on Main Street. Wild Bill was the primary outlaw during much of the park's early years. A man of multiple talents, Wild Bill was also the curator for the Schoolhouse Museum.

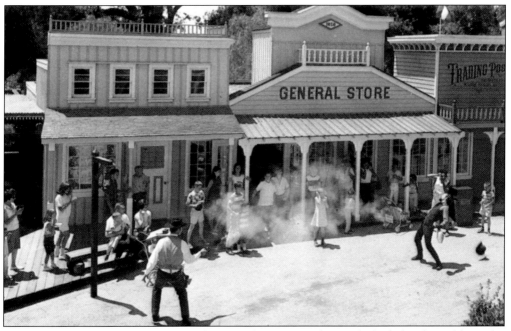

Wild Bill learns crime does not pay during a shoot-out with Marshal Clyde after robbing the General Store on Main Street. He clutches a sack of loot as he falls to the ground. (Courtesy of Allen Weitzel.)

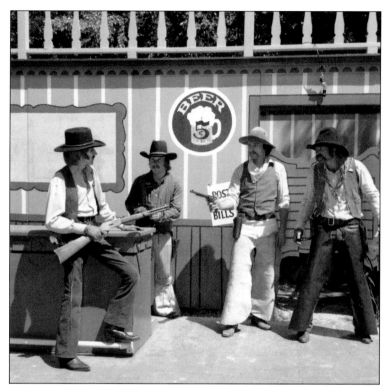

The Fall Guys performed stunt shows in the outdoor Sagebrush Theatre at Frontier Village beginning in 1970. They would do shows only on weekends since they all had regular day jobs. The four members of the group seen here are, from left to right, Chuck Lowe, Bill Perry, Curt Daniels, and Randy Mitchell.

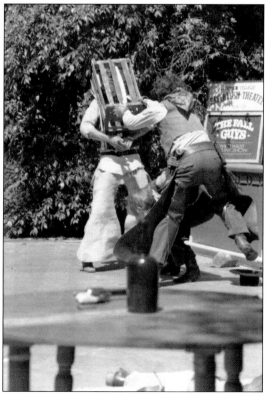

Randy Mitchell administers a breakaway crate to the face of Curt Daniels during one of the stunt shows; Chuck Lowe is between their legs on the ground. All the Fall Guys were self taught. They would be inspired by a scene from television or a movie and then rehearse that move until it worked.

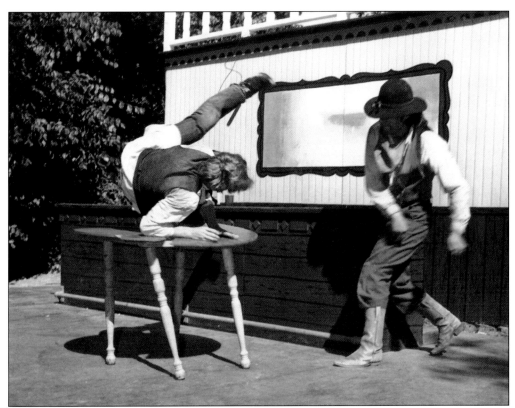

Don Moore falls onto a breakaway table after being punched by Curt Daniels. Performing stunts like this on a hard surface did occasionally cause injuries, and cuts and bruises were not uncommon. A more serious injury such as a knife-fight cut or broken shoulder would require a trip to the emergency room. Chuck Lowe once failed to properly duck from a punch thrown by Daniels, which left Lowe with a broken nose.

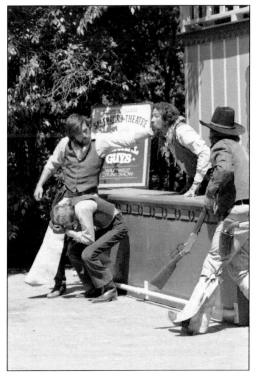

Mayhem breaks out during a free-for-all brawl staged in slow motion at the Red Dog Saloon. Curt Daniels throws a punch at Randy Mitchell as he stands behind the bar, while Chuck Lowe bends over covering his face. On the far right, Bill Perry is about to bring the stock of his rifle into play.

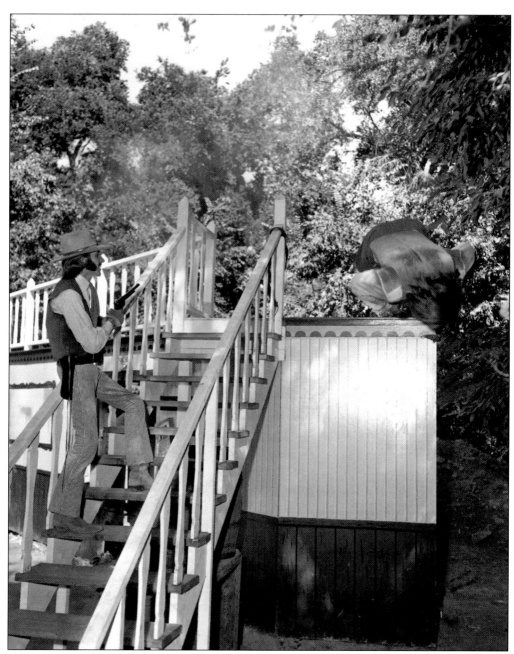

Fall Guy Curt Daniels takes a header off the balcony of the Red Dog Saloon after being shot by Chuck Lowe. The Fall Guys took their stunt show on the road and performed at private parties, corporate events, and once at the Salinas Rodeo. Performing the show at Frontier Village did have the advantage of a large elaborate set with stairs, balcony, windows, and a bar where they could execute more dramatic stunts. After the closing of Frontier Village, the Fall Guys continued to perform at private and corporate events.

Six

COSTUMED CHARACTERS

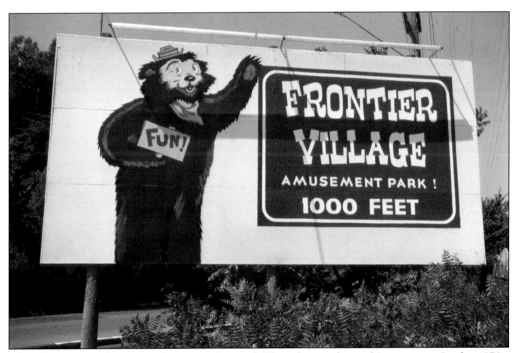

Theodore Bear welcomes park visitors from a billboard near the park's entrance. In the 1970s, Frontier Village began using costumed characters (or body puppets) to roam the park and interact with visitors. Theodore was the first of these characters.

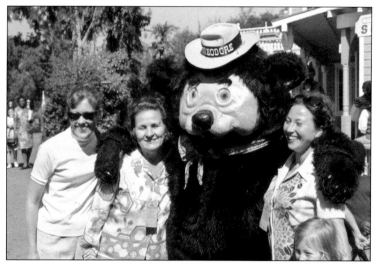

Theodore Bear joined the park in July 1972. He was a fun-loving animal character who enjoyed getting close to visitors. Theodore cheerfully greeted people, posed for pictures, shook hands, and gave big bear hugs. As the park's official host, Theodore provided people with unforgettable moments of their visit to Frontier Village.

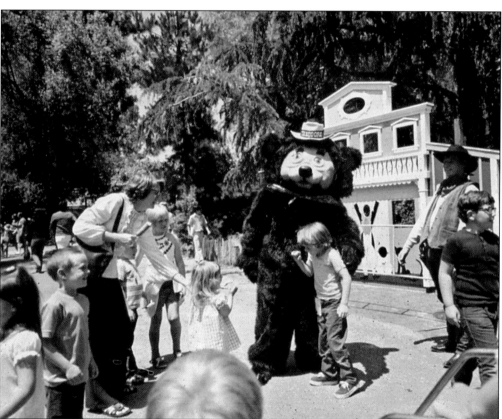

Theodore poses with a young guest, closely watched by his cowboy escort (Greg Cordes) on the right. Theodore was accompanied at all times by an escort known as a "walker." The walker made sure that the character was not overwhelmed by a mob of well-wishers or kicked and punched by overenthusiastic guests. Since the vision from inside the character's head was impaired, the walker would point out overlooked guests who wanted to meet Theodore and help him avoid obstacles he could not see.

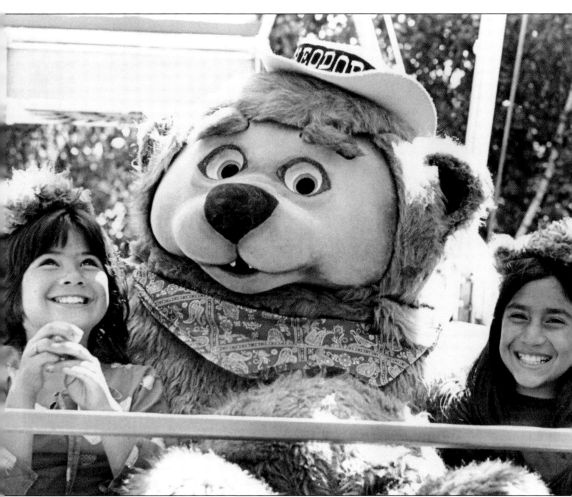

Theodore rides the Ferris Wheel with two guests. He often invited guests to go on rides with him. The problem was that Theodore was a bear, and since bears cannot talk, he used hand signals to communicate with his walker. Rotating his paw meant he wanted to go on the Ferris Wheel. Putting his paws together and pretending to break a stick meant he needed a break. Wearing the six-foot, six-inch costume was physically draining, particularly on a warm day when the interior of the costume became hot and sticky. After 20 to 45 minutes, the person inside the costume needed to go somewhere out of the public eye, where he or she could remove the bear head and take a breather. This photograph was taken in 1974 or later after the dark brown Theodore Bear costume seen in the previous images was replaced with a new one with light tan fur. (Courtesy of Allen Weitzel.)

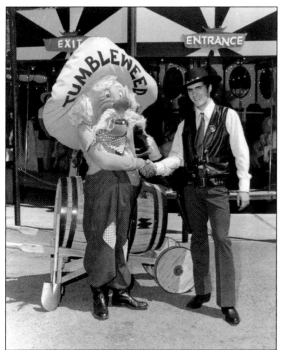

Marshal Westin (Dave Hultquist) welcomes Tumbleweed to the Frontier Village family in 1974. The old miner was created by Village designer Laurie Hollings and built by well-known puppet maker Paul Osborne at a cost of $5,500. Behind Tumbleweed is a barrel mounted on a handcart. That barrel accompanied Tumbleweed everywhere since it was filled with gold nuggets and other treasures excavated by the old prospector.

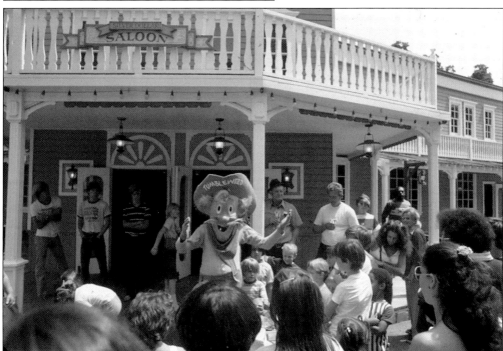

Tumbleweed entertains a crowd in front of the Silver Dollar Saloon. He would stand behind his nugget-filled barrel while a cassette built into the barrel played a prerecorded spiel filled with jokes and puns. As the recording played, Tumbleweed would wave his arms in exaggerated gestures and slap his knee at some atrocious pun. "Have you ever hear tell of Goldilocks? Well, here it is [Tumbleweed holds up a gold-painted lock]. Heh, heh!"

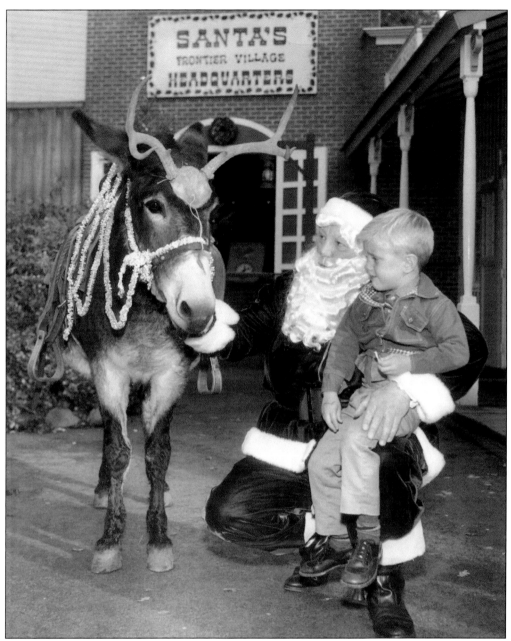

Santa Claus made an appearance each December at Frontier Village. Here, he introduces a young visitor to one of his "burro deer." In the background, the James Transfer and Storage building has been transformed into Santa's headquarters. During December, Frontier Village would be open every weekend for children to enjoy the rides and meet Santa. The park was then open every day during holiday vacation for schools. To encourage visitors during this cold and busy month, Frontier Village did not charge admission during December. (Courtesy of Allen Weitzel.)

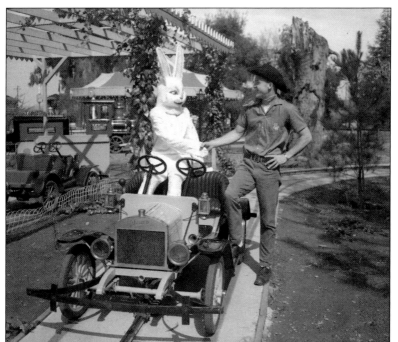

Jim McPhail welcomes the Easter Bunny, who has just arrived at Frontier Village in one of the Antique Autos. The Easter Bunny was in the park every day during the Easter holidays, greeting children and giving out free Easter candy. On Easter Sunday, there was an Easter parade down Main Street, and prizes were given to the best-dressed boy and girl.

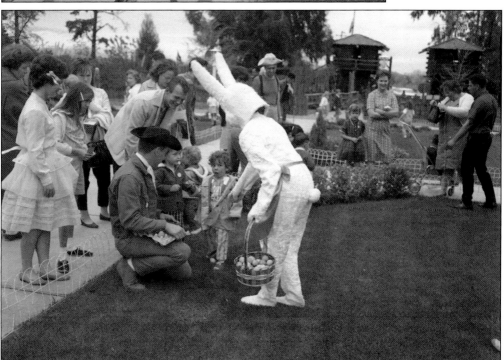

The park sponsored a big Easter egg hunt the day before Easter Sunday. About 3,000 colored eggs were hidden, and kids were divided by age group to make the hunt fair. Prizes were awarded to finders of gold and silver eggs. It was reported that problems did occur during one hunt when eager egg-seekers started removing duck eggs from nests along the water, much to the dismay of the park's resident ducks.

After the movie *King Kong* was released in 1976, Frontier Village general manager Ed Hutton was inspired to add a gorilla to the village's cast of characters. He knew including a gorilla in a Western-themed amusement park would be a stretch, but he then had the idea of naming the character after the cactus, a plant very familiar in Western movies and desert scenes. And since a cactus was green, he decided the gorilla's fur should also be green—a luminescent lime green sure to grab everyone's attention. The costume was manufactured by Scollon Productions with the green fur chosen by Hutton. Thus was born Kactus Kong, a character who brought a new energy and unpredictability to the streets of Frontier Village.

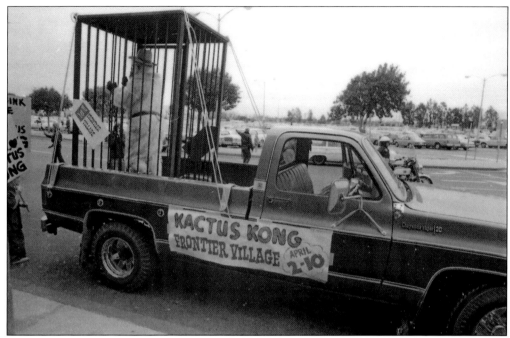

Kactus Kong made his first appearance on April Fools' Day in 1977. He arrived with great fanfare on a banana-colored Hughes Airwest jet at San Jose Airport. After being greeted by a marching band, San Jose State cheerleaders, screaming kids, and representatives of the media, Kactus Kong was led in chains by a Frontier Village marshal to a waiting cage mounted in the bed of a pickup truck (above). He was then driven to Frontier Village under the watchful eye of a police escort (below). It was a memorable event, especially for 17-year-old Frontier Village entertainer Tom Farruggia, the man in the Kactus Kong costume that day. (Both, photographs by Marq Lipton, courtesy of the Tim Stephens collection.)

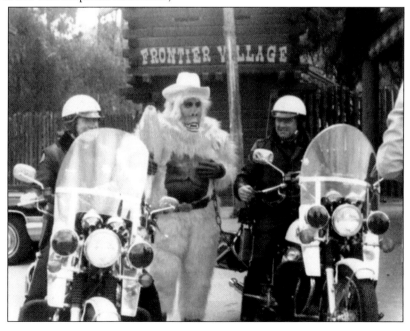

The lighter and less-bulky costume gave Kactus Kong greater freedom of movement than either Theodore Bear or Tumbleweed. He would occasionally perform antics on top of the balcony of the Silver Dollar Saloon (right) or pick up a young guest (below). He waved, danced, and hammed it up for the guests and their cameras. No one knew what this crazy gorilla would do next! In one prearranged PR stunt, Kactus Kong suddenly appeared at a dinner hosted by Mayor Janet Gray Hayes at the Le Baron Hotel in San Jose. Inspired by his movie namesake, Kactus Kong unsuccessfully attempted to kidnap Mayor Hayes.

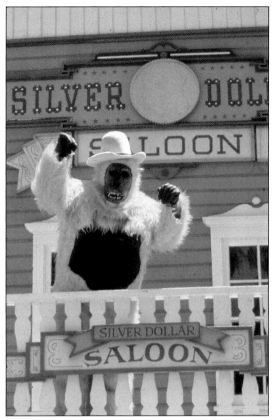

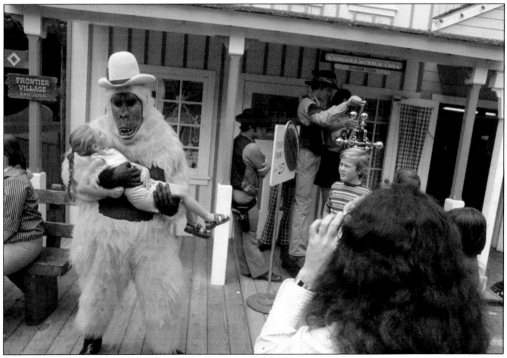

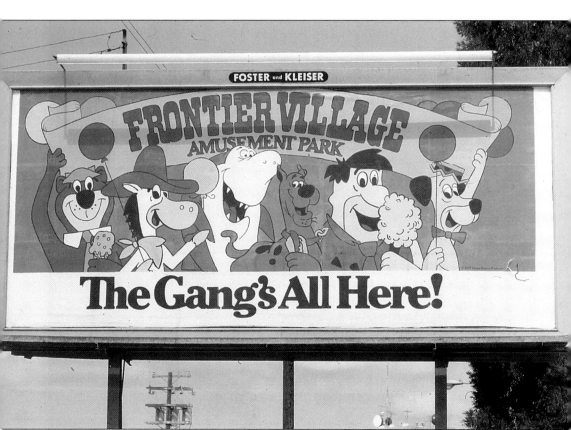

In 1979, six Hanna-Barbera cartoon characters joined the Frontier Village family. As shown on this billboard, they are, from left to right, Yogi Bear, Quick Draw McGraw, Jabberjaw, Scooby-Doo, Fred Flintstone, and Huckleberry Hound. They were first introduced to San Jose on April 6, 1979, when they landed by helicopter in front of San Jose City Hall. The use of these characters was a response to increased competition from Great America by introducing cartoon icons familiar to Frontier Village's core audience of families and children under 12. Ironically, when Frontier Village closed, the performance rights of these Hanna-Barbera characters were then acquired by Great America.

Seven

VILLAGE PEOPLE

This woman, pushing a stroller provided for park visitors at no charge, is a reminder that Frontier Village was, above all, about people. It was a place parents could bring their children to have fun in a safe and clean environment. It was staffed by well-trained people who were welcoming, caring, and enthusiastic. Guests and staff were part of an extended family—the Frontier Village family.

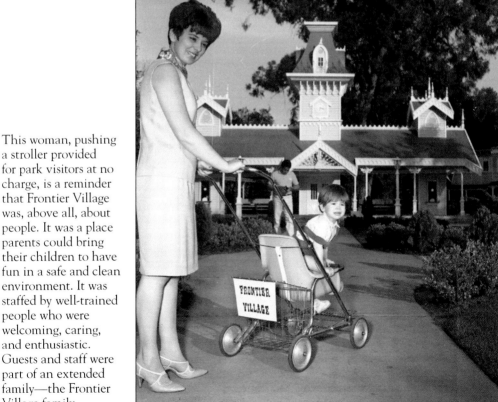

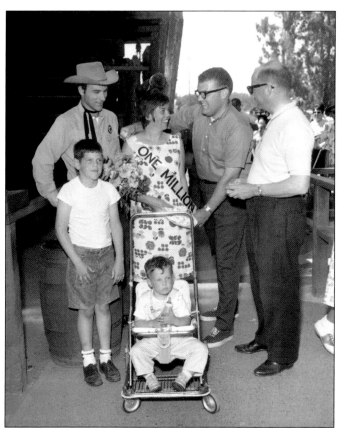

On August 4, 1964, the Cooper family of San Mateo was welcomed by Marshal Clyde and general manager Ed Hutton as the one-millionth visitor to Frontier Village. The Coopers enjoyed free admission, free rides, and a free lunch. They were also awarded an all-expense-paid, two-day trip to Disneyland. Before Frontier Village closed, over five million visitors would walk through its gates.

Frontier Village food service employees prepare to welcome customers to the Silver Dollar Saloon. Female food service employees could be distinguished from other employees by the striped bows worn in their hair. Despite its name, when it first opened, the Silver Dollar Saloon served nothing stronger than soft drinks.

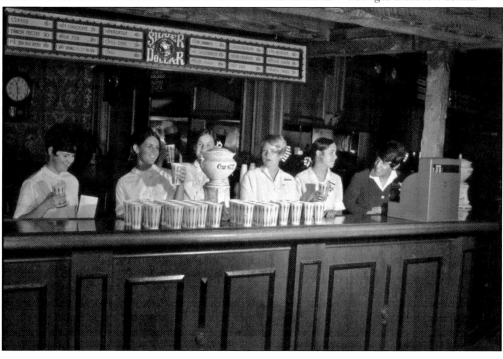

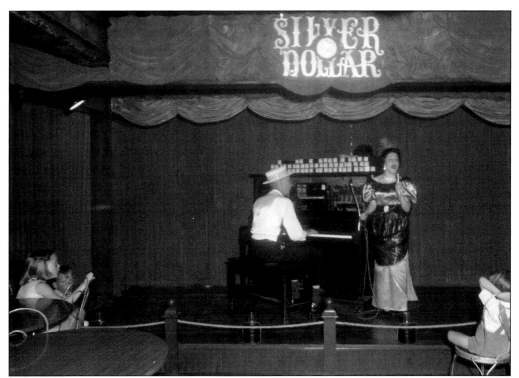

Besides food and drink, patrons of the Silver Dollar Saloon could find entertainment such as Diamond Lil, played by Sharon (Cressio) Rodda, who is singing for customers, accompanied by an unidentified piano player (above). When Diamond Lil was not on performing, the Silver Dollar Saloon Dancers could be found on stage (below). During the summer, the dancers did three shows a day during the week and five shows on weekends. In the winter, they did three shows a day on weekends. With this kind of schedule, it is not surprising the dancers had worn out their costumes one year after the park opened. In this photograph, taken in either 1962 or 1963, are from left to right, Gale (Burrow) Kaiser, Linda (Maxfield), Mahaila (Tello) McKellar, and Robin (Nice) Romero. (Below, courtesy of the Sourisseau Academy, San Jose State University.)

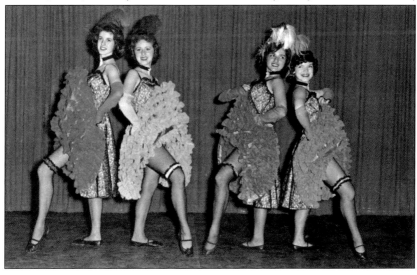

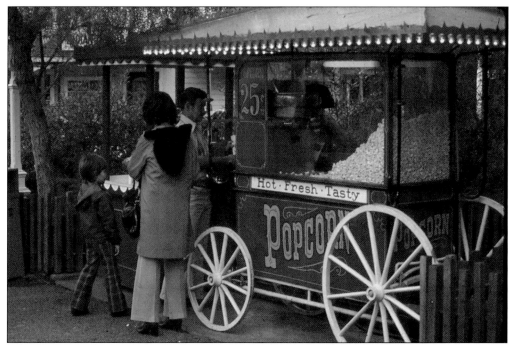

Visitors could purchase hot buttered popcorn at two popcorn wagons in the park. The wagons looked vintage but were actually modern replicas manufactured in Chicago.

At this refreshment stand, guests could buy soft drinks, chips, candy apples, and other snacks.

Frontier Village often hosted school and community events. For example, every year, the park welcomed hundreds of students from fifth to eighth grades who were members of the School Safety Patrol. Here, members in uniform line up at the park's entrance and are greeted by a representative of McDonald's, who was also a sponsor of the event.

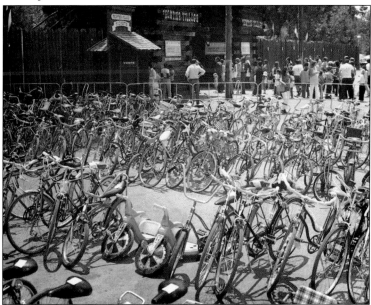

A large number of bicycles are parked in a special area outside the entrance of Frontier Village during Bicycle Safety Day. This event was held in the mid-1970s and sponsored by a local television station. (Courtesy of Allen Weitzel.)

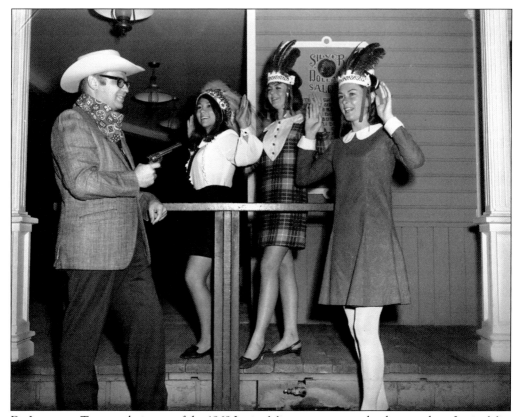

Dr. Lawrence Turpen, chairman of the 1969 Junior Miss pageant, gets the drop on three Junior Miss contestants in front of the Silver Dollar Saloon. From left to right are Nancy Joe Salvador, Debbie Westercamp, and Jenny Phillips. At the pageant finale, Phillips was named second runner-up.

Maintenance man Mike Barton checks the width of the railroad tracks of the Frontier Village train. Keeping the correct gap between the tracks prevented derailments. This is an example of the safety checks done during the off-season and whenever the park was closed. (Courtesy of Allen Weitzel.)

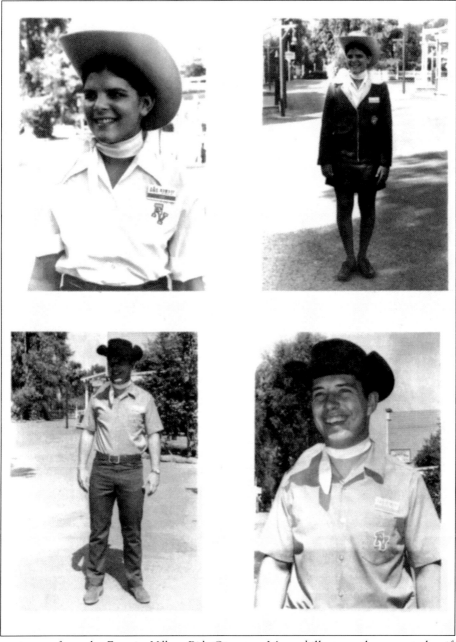

These pictures from the *Frontier Village Ride Operators Manual* illustrate the expected uniforms and appearance of ride operators, as modeled by Jane Gwinn and Mike Hassel. All operators were required to wear cowboy/cowgirl hats. Special attention was also paid to the folding and placement of the neckerchief, with ends hanging on the right side of the neck. The park would hire about 350 part-time employees each season, and 90 percent of them were high school or college students 17 years of age or older. The park tried to hire friendly, neat, and clean-cut youngsters who were comfortable greeting visitors, posing for the occasional photograph, and above all providing visitors with an enjoyable experience. All Frontier Village employees, from secretaries to managers, would greet visitors not with "Hello" or "Hi," but with the Western-friendly "Howdy!"

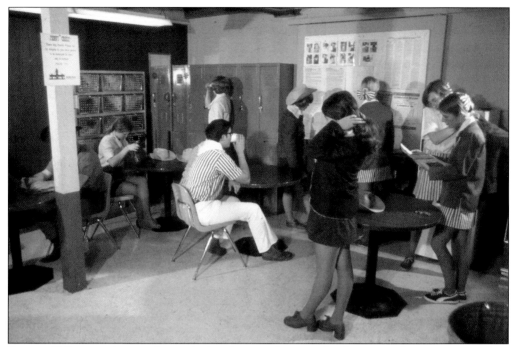

Frontier Village employees relax in the break room. Surveys of park visitors always commented on the friendliness of park employees. Managers enjoyed telling the story of a female ride operator who lost her balance walking down the stairs of the Round-Up. After bouncing down the steps on her behind, she paused, looked up at the concerned people waiting in line, and with a big smile said, "Howdy!"

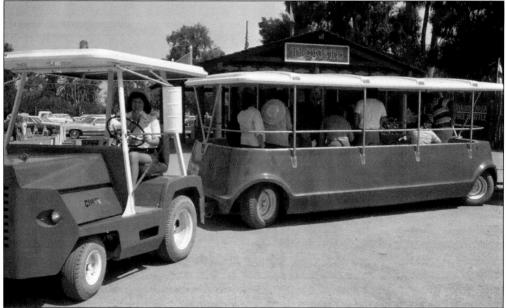

As attendance grew, the Frontier Village parking area had to be expanded, so shuttle buses were used to bring guests to and from the parking area. At Frontier Village, parking was always free. Shuttle bus drivers were usually women, as the male drivers hired tended to drive too fast.

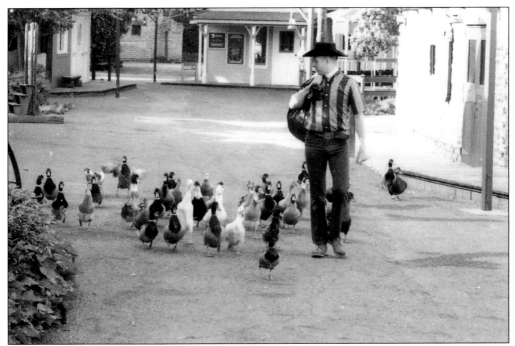

Operations manager Warren Weitzel attracts quite a following of Frontier Village's resident ducks as he walks down the street, carrying a large plastic bag (above). The ducks know that the bag is full of popcorn, bread, and other edibles left by park visitors. The ducks enjoy the feast (below), keeping the park clean and garbage out of the local landfill. (Both, photographs by Marq Lipton, courtesy of the Tim Stephens collection.)

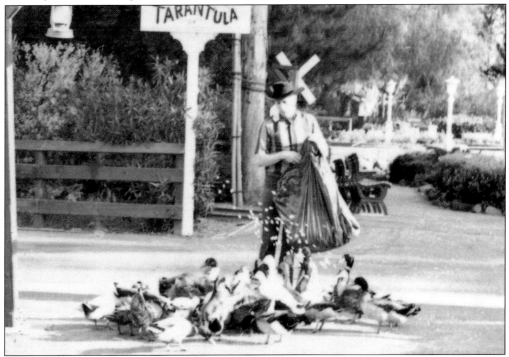

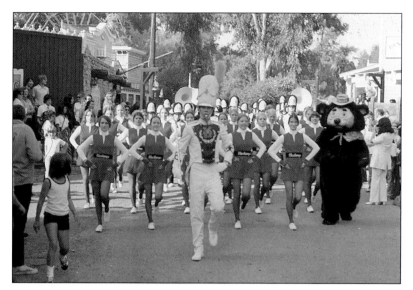

Theodore Bear accompanies one of the high school bands marching down Main Street during Frontier Village's High School Band Day, held annually in October.

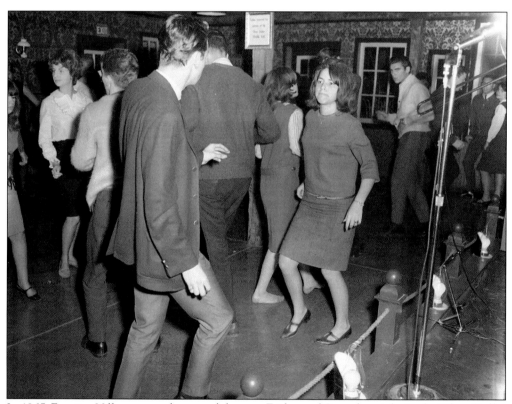

In 1965, Frontier Village opened a teen club every Friday and Saturday night in the Silver Dollar Saloon, admitting teenagers 16 to 19 years old. The dress code required young men to wear ties with either a sweater or sports coat and the young women to wear either a dress or sweater and skirt. Food and soft drinks were available. In later years, the park became a popular venue for all-night high school graduation parties.

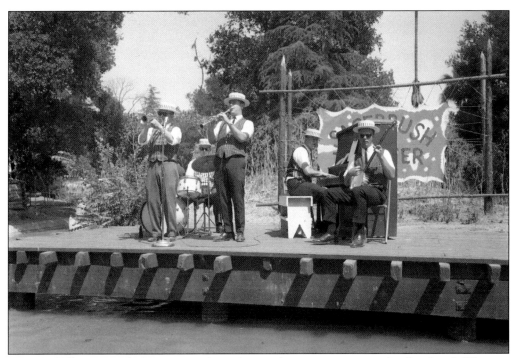

Frontier Village provided visitors with professional entertainment at the Sagebrush Theatre, located next to Indian Island. One of the groups that played early in the park's history was the Keith Kittle Dixieland Band (above), with Keith Kittle on piano. Another group to play on the Sagebrush Theatre stage was the California beach party band Papa Doo Run Run (below). This performance took place later in the park's history after the backdrop for the Fall Guys Stunt Show had been built.

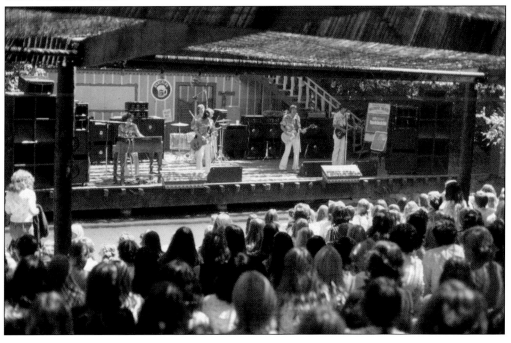

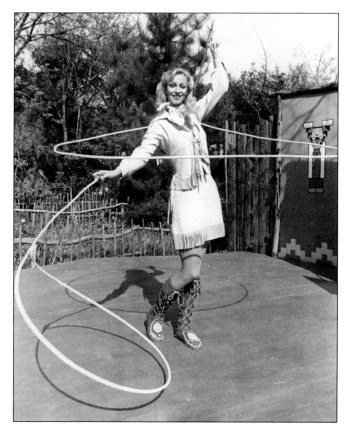

Chyrle Bacon shows off her trick-roping skills on the Indian Island Stage. Bacon could also demonstrate her expertise with cracking a whip. In 1993, she set a world record by creating a lasso with a 70-foot loop. Cowgirl Chyrle continues to perform shows today. (Courtesy of Allen Weitzel.)

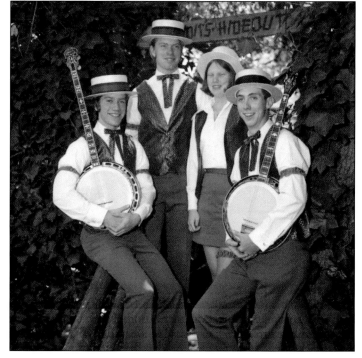

The Gaslite Gang started playing at the Silver Dollar Saloon in 1975 and quickly became the saloon's main weekend act. They sometimes played as roving street musicians and would fill in at the Sagebrush Theatre on short notice when another musical group had cancelled. The members are, from left to right, Kevin McCabe (plectrum banjo), Bruce Jolly (string bass), Debbie Hartford-Weitzel (piano), and Scott Hartford (tenor banjo).

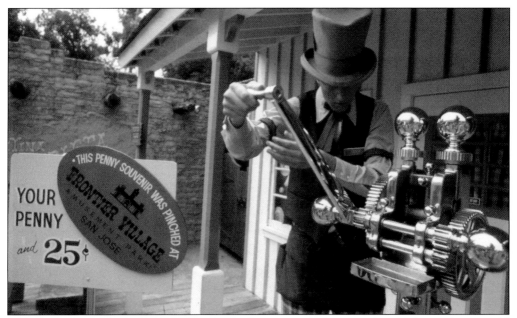

The gentleman with the big hat is operating the penny-pinching machine. The machine would take a visitor's penny and send it through two steel rollers, flattening it into an elongated piece of metal. The blank piece of metal would then be die stamped with the oval engraving shown on the sign to the left. The result was a unique souvenir of Frontier Village, all for the price of 25¢, plus one penny.

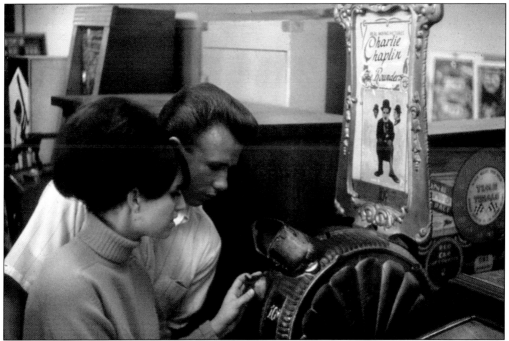

A young couple shares a view of a Charlie Chaplin short on an antique movie machine in the Arcade. The Arcade on Main Street featured a number of old-fashioned mechanical devices and skill machines.

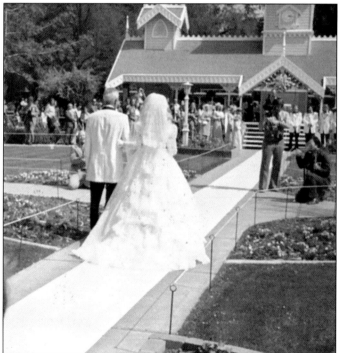

A young podner celebrates his birthday in the Frontier Village Birthday Corral.

On a sunny day in April 1973, Jackie Levensailor and Bill Izzarelli were married on the steps of the Frontier Village Train Station. The bride and her father arrived by stagecoach and the groom and his best man by railroad. Theodore Bear served as "ring bear." The marriage was observed by 200 invited guests and 1,000 park visitors. After the ceremony, the bride and groom rode several rides and then attended a reception held in the Silver Dollar Saloon. (Courtesy of Allen Weitzel.)

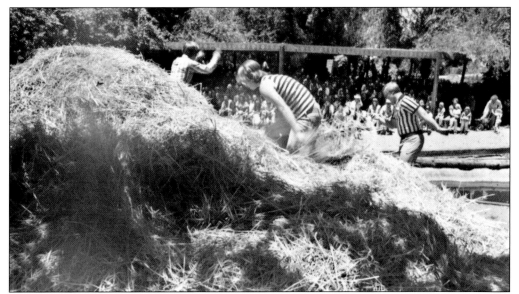

Families search a giant haystack on the stage of the Sagebrush Theatre trying to find the elusive needle in a haystack. Twelve families were picked for this contest. They had two minutes to find the special knitting needle hidden within the haystack. Winners received special prizes, including a color television and a Mississippi River cruise on the *Delta Queen* riverboat.

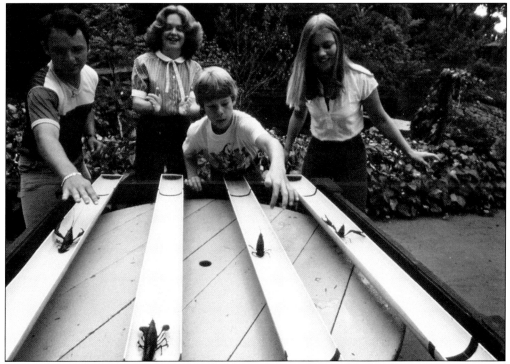

Crawdad owners cheer on their charges during the Frontier Village World Championship Crawdad Race held on the Indian Island Stage. The crawdads raced down a 100-centimeter track, competing for the trophy honoring "the Crustacean That Won the West." Overseeing the race in the striped shirt is Joanie (Nelson) Schuller.

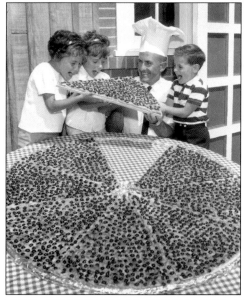

Eight-year-old twins Vickie and Terry Sartor (left) and their six-year-old brother Rich pretend to take a bite out of a giant Me-n-Ed's Pizza, watched by Me-n-Ed's cofounder Russ Johnson. The pizza was set up next to the Marshal's Office, and visitors were invited to guess the number of olives on the pizza. The winner was 13-year-old Jeanne King of Truckee, who won a lifetime supply of Me-n-Ed's pizzas. (Courtesy of the Tim Stephens collection.)

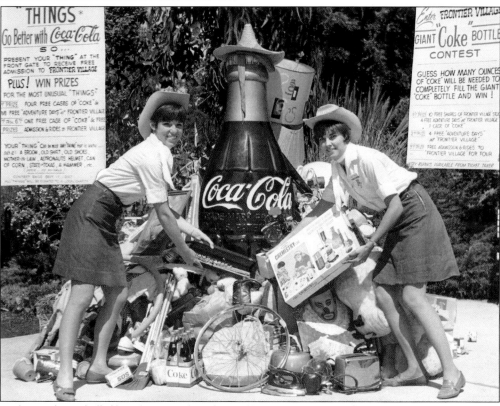

Barbara Edmunds (left) and Karen Shea show off some items entered in Frontier Village's annual Things Go Better with Coke Contest. Visitors who brought a usable item or "thing" were given free admission, with the most interesting item winning prizes. Visitors could also guess the number of ounces contained in the giant Coke bottle for more prizes. At the end of the contest, all the items were donated to charity. (Courtesy of Allen Weitzel.)

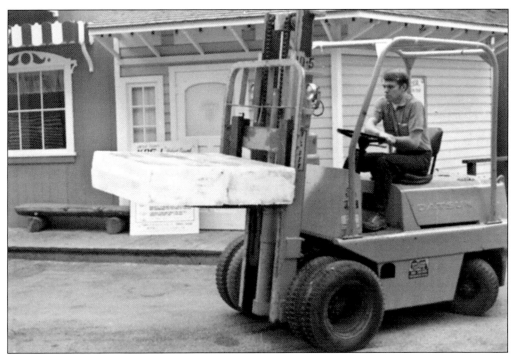

Frontier Village employee Rich Chadwick (above) carefully maneuvers a forklift carrying a large piece of ice to add to the growing pile of ice slabs for Frontier Village's Ice Melt Contest. Cheryl Taylor (below) coolly perches on the seven-ton stack of ice. Visitors were encouraged to enter the contest by guessing how long it would take all of the ice to melt. The winner that year was Alberta Marie Zmarzly of Sunnyvale, who came within one minute of guessing the actual melt time of seven days, 12 hours, and 29 minutes. This was a popular Frontier Village contest, although one woman leaving the park was overheard remarking that she could not understand why it took her husband one hour to figure out how long it would take for the ice to melt! (Above, courtesy of Allen Weitzel.)

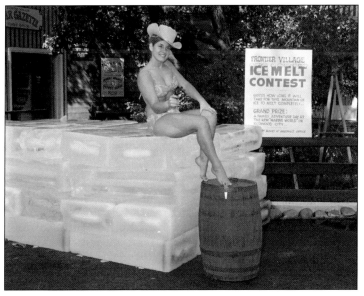

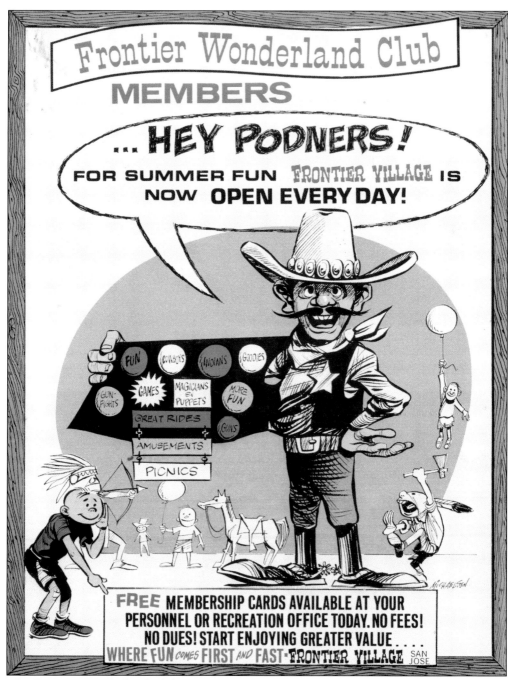

The Frontier Wonderland Club was one of the park's longest running and most successful marketing efforts. The club was available to businesses and organizations with 250 employees or more. Frontier Village supplied each organization with membership cards, posters, brochures, and other promotional materials. The free membership cards gave employees discounted prices on Frontier Village admissions and rides. In the late 1970s, over 1,200 organizations were members of the Frontier Wonderland Club.

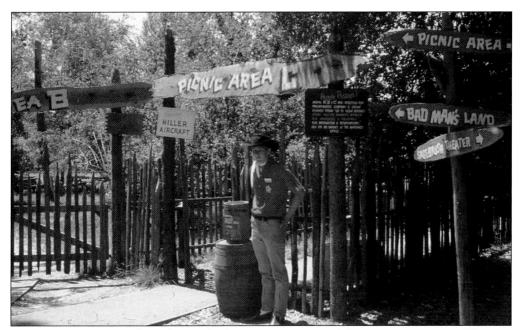

A picnic-area gate guard stands outside the entrance to one of the group picnic areas. The gate guard would greet guests entering, check to see they were at the right place, and take their "Picnic Area Admission" ticket. He would then ink stamp the back of their hands, which allowed guests to leave and reenter. He also prevented alcoholic beverages from leaving the picnic area.

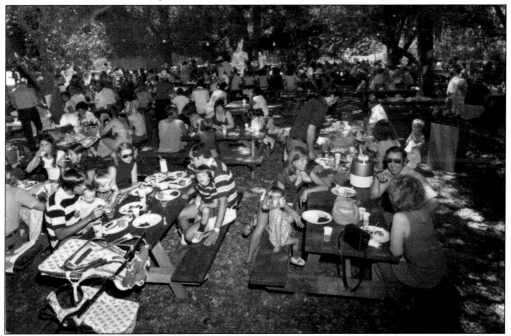

Group picnics generated a large portion of Frontier Village business. There were six private picnic areas for company and group events that could accommodate up to 5,500 people. The group picnic season began in April and extended through the end of October, with the summer months being the busiest.

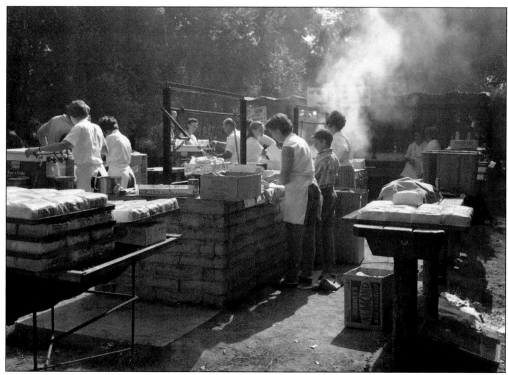

Several of the group picnic areas had barbeque pits for organizations that wanted to bring and cook their own food (above). Many organizations choose to have Frontier Village cater their event instead (below). A typical Frontier Village catered menu included a meat dish, barbeque beans, salad, bread, and dessert. Among the meats available were chicken, steak, hot dogs, hamburgers, and barbecue beef sandwiches. The salads might be tossed green, potato, macaroni, or coleslaw. Frontier Village food servers prided themselves on serving tasty meals to large groups in a timely manner, serving up to 2,000 people an hour. Beverage service was available for an extra charge. Frontier Village was one of Olympia Brewery's largest customers, serving up to 90 kegs a day.

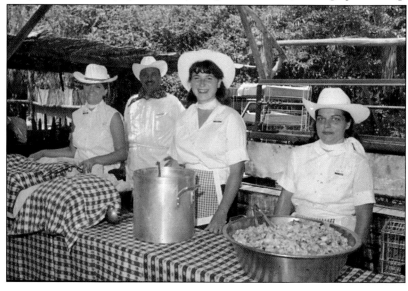

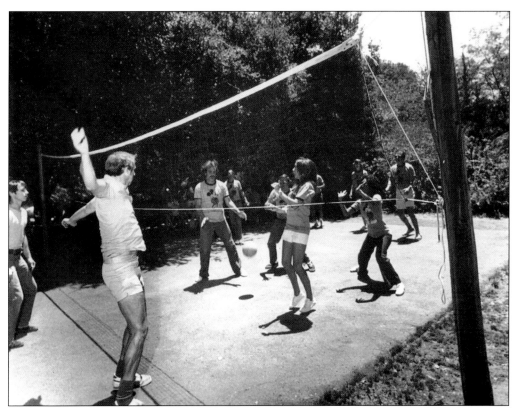

Picnic area guests had access to volleyball areas and horseshoe pits. Equipment for these sports could be checked out at the area's beverage stand. It was also possible for groups to reserve the park's softball diamond.

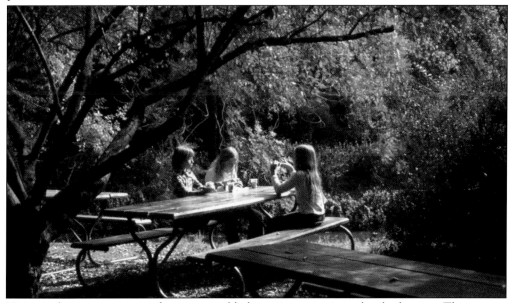

Visitors who were not part of a group could also enjoy a picnic under shady trees. There was a picnic area to the left of the Main Gate that all park visitors could use free of charge.

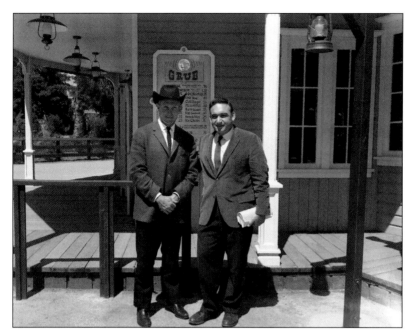

Over the years, Frontier Village played host to a number of celebrities. Here, Frontier Village president Joe Zukin (right) poses with football great Y.A. Tittle in front of the Silver Dollar Saloon. Tittle visited Frontier Village on June 28, 1963.

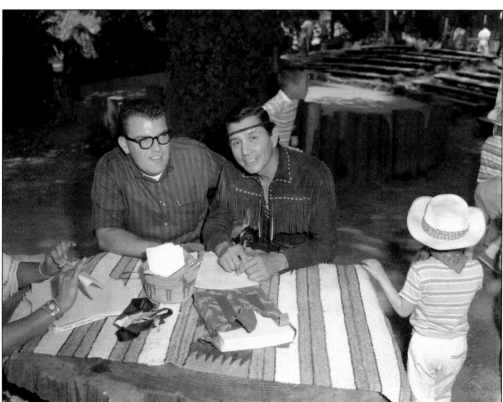

Jay Silverheels (right) signs autographs for fans at a table. Sitting next to Silverheels is park public relations and advertising manager Ed Hutton. Jay Silverheels played Tonto on the popular TV western *The Lone Ranger*. He visited the park on June 15 and 16, 1963.

Two of the "Sweathogs" from the *Welcome Back Kotter* TV series paid a visit to Frontier Village on June 6, 1976, to sign autographs. Appearing were Lawrence Jacobs (left), who played Freddie "Boom Boom" Washington on the show, and Robert Hegyes, who played Puerto Rican Jew Juan Epstein. (Courtesy of Allen Weitzel.)

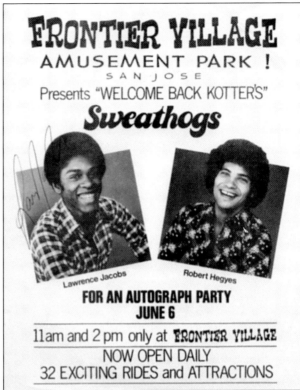

San Francisco disc jockey Al Collins (right) receives a souvenir paddle from Indian Jim. Al "Jazzbo" Collins had a very popular radio show on KSFO in the early 1960s. He also hosted a morning TV show on KGO at the same time. The first-annual Al Collins Listeners Convention held at Frontier Village in July 1977 attracted 6,000 fans.

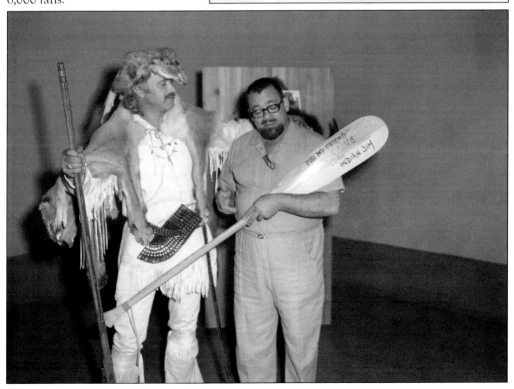

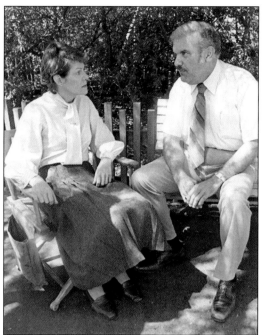

Lynn Redgrave (left) chats with park general manager Ed Hutton during a break between scenes of the CBS made-for-TV movie *The Seduction of Miss Leona.* Redgrave plays a college professor who falls in love with a maintenance man. Some scenes were filmed at the Frontier Village Ferris Wheel. Additional scenes were filmed locally at Foothill College and Reid-Hillview Airport. The movie was later released as a videocassette under the title *To Love Again.* (Photograph by Marq Lipton, courtesy of the Tim Stephens collection.)

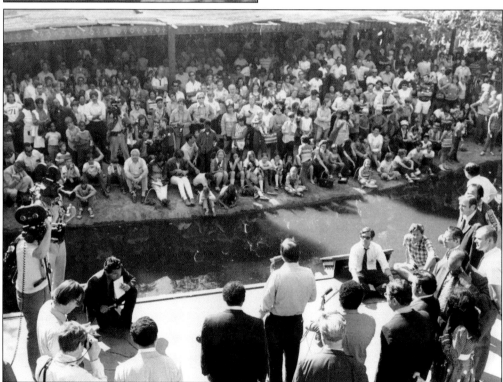

Presidential candidate Hubert Humphrey (in white shirt facing the crowd in the lower center) makes a campaign speech from the stage of the Sagebrush Theatre in Frontier Village on May 29, 1972, prior to the California June Primary. The listening crowd numbered 400 to 500 people. (Courtesy of Allen Weitzel.)

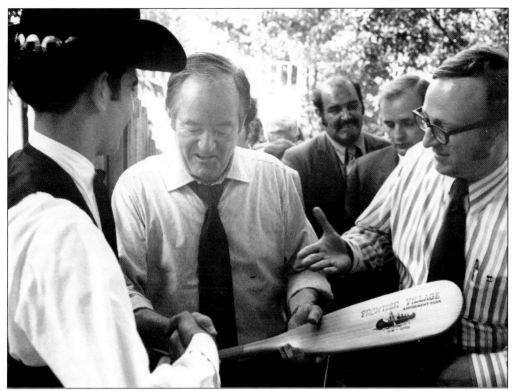

Hubert Humphrey receives a souvenir Frontier Village canoe paddle during his visit. From left to right are Marshal Westin (Don Gwinn), Hubert Humphrey, and marketing director Keith Kittle. There is a small pin on Kittle's shirt pocket to the right of his pen that was supplied by the Secret Service to indicate that Kittle could have up-close access to the candidate. It was a warm day, so Humphrey had taken off his jacket and loosened his tie.

Keith Kittle (left) greets actor Lorne Greene. Greene, who had introduced Humphrey during his Frontier Village campaign appearance, played patriarch Ben Cartwright on the hit Western television series *Bonanza*. Instead of a souvenir canoe paddle, the actor received a more appropriate Frontier Village deputy marshal badge, which he is wearing on his lapel. Greene was reportedly a good sport about the holes the badge pin made in his leather jacket. (Courtesy of the Tim Stephens collection.)

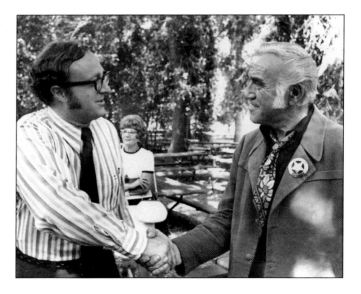

Billboard advertising was an important part of Frontier Village marketing. These two billboards stood on top of a building at the corner of Harrison Street and the Alameda near Santa Clara University. One billboard dates to the early 1960s (above) and the other to the mid-1960s (below).

Eight

THE LAST ROUND-UP

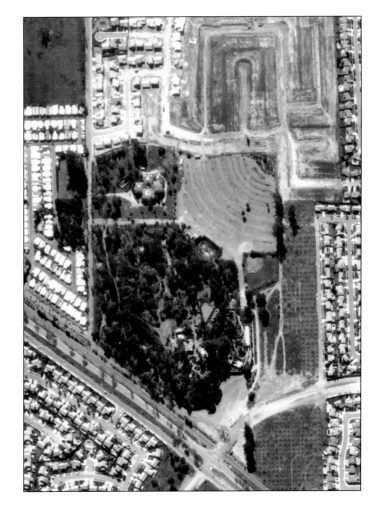

By the late 1970s, much of the empty land that originally surrounded Frontier Village had been developed. The empty land northeast of the park that had once been a drive-in theater was now being used for parking. Rio Grande Industries, the parent company of Frontier Village, proposed expanding the park into this area, as well as land north and east of the current park; however, residents in the nearby subdivisions vehemently opposed any plans to expand.

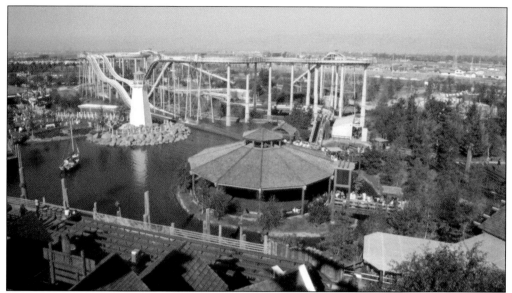

The 1976 opening of Marriott's Great America 15 miles north in Santa Clara was a major challenge to Frontier Village. The bigger Great America had room for large "hard" thrill rides, which attracted enormous crowds. The first year both parks were open, attendance at Frontier Village dropped 19 percent. Frontier Village attendance slowly recovered over the following years, and the park continued to show an annual profit.

In order to remain competitive, in 1975 parent company Rio Grande Industries proposed a major expansion of Frontier Village. The park would grow from 49 to 101 acres, making room for more parking and additional rides. Examining a model of the planned expansion are, from left to right, park designer Laurie Hollings, Dave May of the South Valley Chamber of Commerce, and Frontier Village general manager Joe Zukin. (Courtesy of Allen Weitzel.)

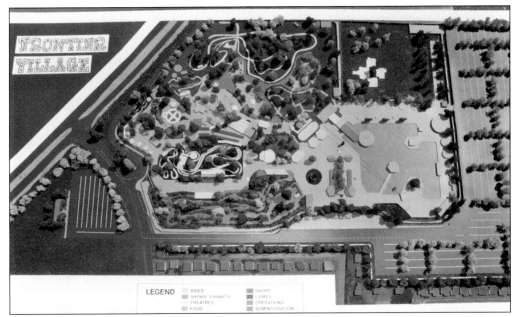

The $10 million expansion would be phased in over five years. It would bring more sophisticated rides that appealed to teenagers while keeping the family-friendly atmosphere that had always been Frontier Village's greatest appeal. Besides the new rides, the expansion would also include a five-acre man-made lake. Park attendance was projected to rise from 500,000 annually to 1.5 million.

The expansion plans met with vocal opposition from neighborhood groups that said it would bring increased traffic, crime, and noise to the area. Frontier Village revised the plans to include a 14-foot sound barrier and a 40-foot-wide landscaped berm between the park and its nearest neighbors. It would also limit ride heights to 45 feet and place all rides in the center of the park to minimize their impact.

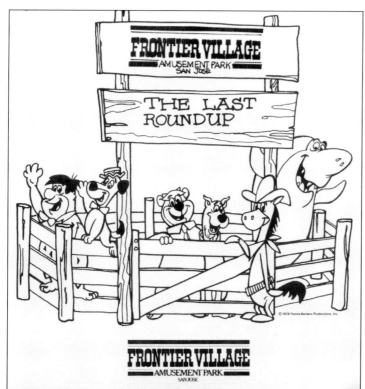

The expansion plans were eventually approved, but they required the park to spend $1.8 million on traffic improvements and noise mitigation in addition to the $10 million required for park expansion. Rio Grande declined to spend the additional money and decided the land was too valuable to be used as an amusement park. The land was to be sold and Frontier Village closed. The final season was to be the "Last Round-Up."

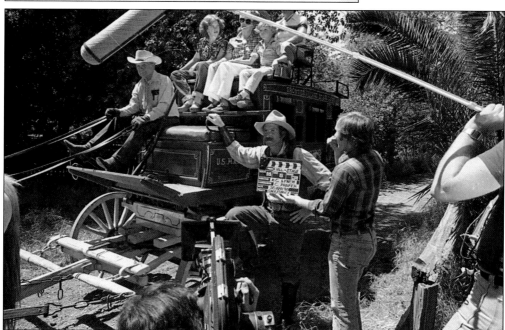

Frontier Village shot two commercials to publicize its final season. In one, a prisoner bemoans the fact that by the time his sentence is up, Frontier Village will be closed. The other commercial was more nostalgic, with Randy Mitchell boarding the stagecoach for one last ride with driver Paul Stolp. (Photograph by Marq Lipton, courtesy of the Tim Stephens collection.)

```
MERCHANDISE, GAMES AND ENTERTAINMENT EMPLOYEES

THIS WEEKEND MARKS THE END OF AN ERRA....
MANY PARKS HAVE FANTASTIC RIDES; WE HAVE
FANTASTIC EMPLOYEES. FRONTIER VILLAGE EMPLOYEES
AND STAFF HAVE SET A STANDARD FOR QUALITY GUEST
SERVICE, THAT WILL BE REMEMBERED LONG AFTER THE
TREES, RIDES AND BUILDINGS ARE GONE.

THANK YOU FOR MAINTAINING OUR STANDARDS UP TO AND
INCLUDING OUR LAST OPERATING DAY.

WE MAY FORGET THE RIDES AND THE TREES, BUT WE
WILL NEVER FORGET THE FRIENDS WE'VE MET
IN OUR SEASONS WITH THE PARK.

THANKS FOR STAYING THROUGH THE LAST ROUNDUP.

BEST WISHES,

ALLEN
```

The final season was a busy one, with attendance averaging 30,000 a week, as parents and families wanted to enjoy the park one last time. But the end came on September 28, 1980, when after 19 years Frontier Village closed forever. In this short memo, Allen Weitzel, director of merchandise, games, and entertainment, sums up the bittersweet feelings of the Frontier Village staff. (Courtesy of Allen Weitzel.)

Frontier Village employees pose for a "Last Round-Up" group portrait in front of the train station.

125

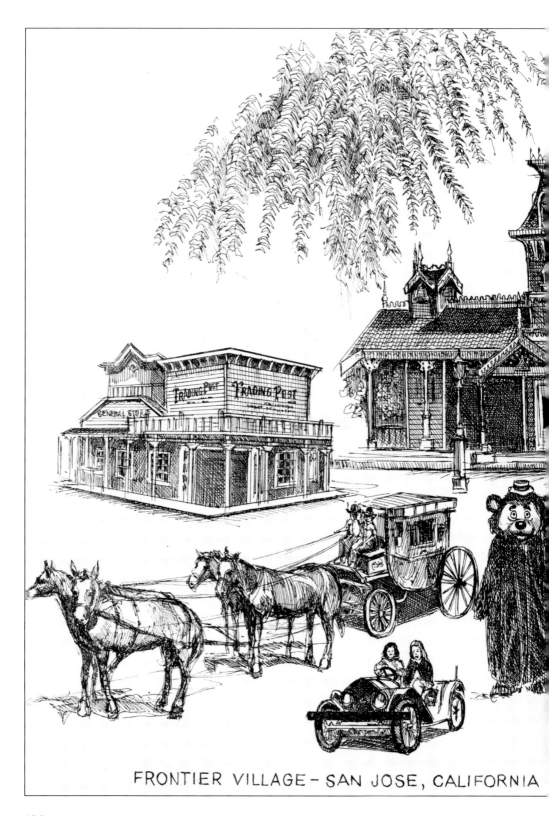

FRONTIER VILLAGE – SAN JOSE, CALIFORNIA

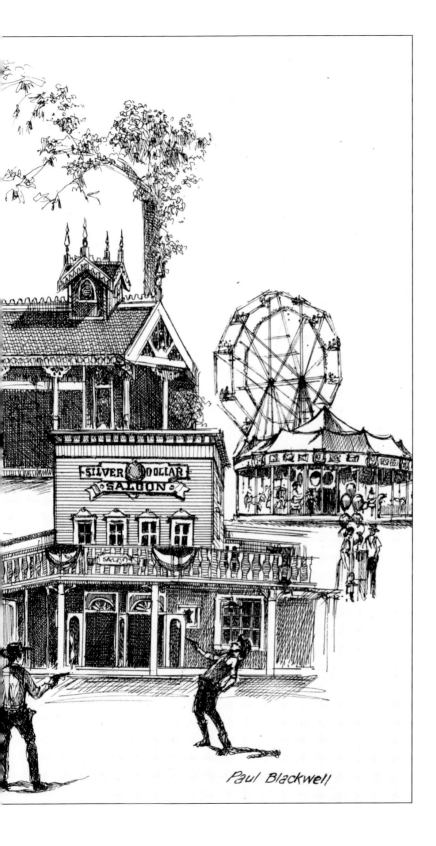

Paul Blackwell

Discover Thousands of Local History Books Featuring Millions of Vintage Images

Arcadia Publishing, the leading local history publisher in the United States, is committed to making history accessible and meaningful through publishing books that celebrate and preserve the heritage of America's people and places.

Find more books like this at
www.arcadiapublishing.com

Search for your hometown history, your old stomping grounds, and even your favorite sports team.